dennis hopper

rudi fuchs

jan hein sassen

dennis hopper *(a keen eye)*

artist, photographer, filmmaker

Stedelijk Museum Amsterdam

NAi Publishers Rotterdam

HUGO BOSS

This intriguing exhibition and this publication of work by the multitalented Dennis Hopper represents
the fruit of many years of friendship and cooperation between the artist, the Stedelijk Museum
Amsterdam and HUGO BOSS.

We all know Dennis Hopper as a gifted actor and director. We also know his film Easy Rider with
Peter Fonda and Jack Nicholson, a work that established his cult status within the Beat generation.
Very few people, in contrast, know the painter and photographer who chronicled the Beat culture in
southern California and the budding art scene in Los Angeles. It was in this role that Dennis Hopper
captured the spirit of that moving era like no other.
Discovering Dennis Hopper the artist has been an exciting and inspiring experience for us.

Our very special thanks are due to Rudi Fuchs, the Director of the Stedelijk Museum Amsterdam, and
to Jan Hein Sassen, who has acted as curator for this exhibition. We are also grateful to all the people
who have teamed their energies to make the project a success.

This is the first time that the entire scope and spectrum of Dennis Hopper's work has been shown in
a single exhibition and featured in a single publication. We are certain that you too will find the many
facets of his art both fascinating and enjoyable.

Werner Baldessarini
Chairman of the Management Board
HUGO BOSS AG

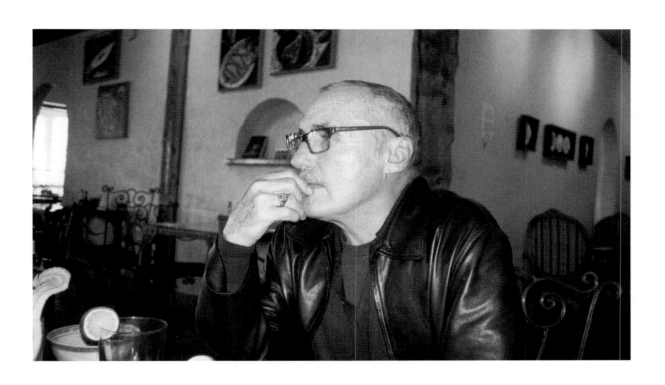

Cemetery, 1997
triptych of digitized video stills on canvas
from *Easy Rider*, 1969, ed.1/3
30.5 x 40 inches (each)

back and forth

rudi fuchs

There is simply no way of getting around *Easy Rider*. In conversations with Dennis Hopper as well, that legendary film from 1969 keeps on cropping up: as a breakthrough to himself, as his own declaration of independence. The film has cardinal significance in his life; it situates other things in time. After *Easy Rider*, he said, I stopped taking photographs. He was referring to the black-and-white photographs from the sixties: portraits of friends from the Los Angeles art world, but then staged in the way in which he was making other photographs at the time, of places and situations in the city's landscape. When I started taking photographs in 1961, he said, I stopped painting. In 1961 Hopper was living in Bel Air (Hollywood). There was a fire in his studio, and in it three hundred paintings were lost, almost everything that he had produced. When Hopper talks about his life as an artist, it is often about such interruptions– as though no sort of order or calm has ever come about in that life.

My first encounter with him took place a few years ago in a small gallery in Kassel, where new photographic works (1996-97) were being shown: large glossy shots, in color, of walls with scrapings, splatters, graffiti, peeling paint. What I had to think of that work, I didn't know. In terms of his aesthetics, it resembled, to a certain extent, the *décollages* of the early sixties, a version of abstract expressionism in a realistic form. But, at the same time, it was also different. In those photographs one could discern a rigid and precise control–and a strange intensity of observation. Aside from that work, I was then acquainted only, and superficially, with the photographs from the 1960s. Those I regarded, in my ignorance, as a commentary from a fascinating period, the emergence of the West Coast as a place for art, made by a movie star who was acting as an observer and collector. But the intensity of the man began to interest me.

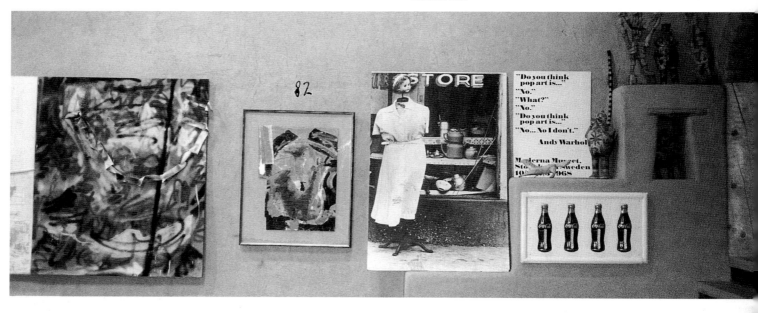

That evening or the next day, when we met each other again, I proposed that he make an exhibition in Amsterdam. On this occasion he spoke warmly about his early friendship with Ed Kienholz–and told me that he also made paintings. Actually, he said, his ambition had been to become an artist, but in order to make money he had ended up in Hollywood. Whether that is entirely true, I don't know. But after all of the conversations with Hopper that followed, I do know that that remark is, in any case, not *untrue*. This is how it grew: the idea of making an exhibition about that complex of circumstances, about an artist who produces paintings and assemblages and photographs but who is famous in the world as an actor and director of, among other things, the emblematic film *Easy Rider*. In the world of visual art, Hopper had a certain reputation as the photographer of the West-Coast scene. In Europe this was mostly an exotic one, the reputation of a legendary filmmaker who, more or less on the side, also produced photographs which, in their form of observation, were reminiscent of images from *Easy Rider*. That was comprehensible. But he sent me several photographs of his paintings. These gave me the impression of a morphology, or a visual language, that had taken shape with him before *Easy Rider*. That was what began to intrigue me and what began to determine, as a literal theme, the gist of our conversations. The exhibition would be about the artist Dennis Hopper. This had not yet been defined. That artist was a man who is actually a painter but who may have been hampered in this activity by the film legend. By this time I was certain that this was not a Hollywood celebrity who, on the side, produced art as well. That image did not correspond at all to the tone of our conversations and to what I gradually came to see. More and more, it became clear that Dennis Hopper is a true artist, who has been hindered in the development of his artistry due to, among other things, his work in film. At least it seemed that way. This was the only way in which I could understand how he describes his career over the years: After *Easy Rider* I stopped taking photographs; after the fire in Bel Air I didn't paint for

a long time; only after the film *Colors* (1988) did I start making paintings again. But we can also describe that development differently–and that is, in part, what our conversations were about. I began to understand that the films which he directed were part of his work as an artist. The rigid and unfashionable way in which he photographed street scenes during the 1960s is an extension of the crude design of paintings and assemblages from an earlier time–and those crop up again in the filmic design of *Easy Rider*. We are dealing, in fact, with a consistent visual language which manifests itself in its own way in different media, without any evidence of an aesthetic contradiction. Dennis Hopper glides from one medium into the other when a different medium offers him better opportunities to portray intense emotion. The paintings done before 1961, the few that remain since the fire in Bel Air, had an abrupt and even aggressive design which, he noticed, would be more aptly suited to black-and-white photographs. Those ruthless photographs, void of sentimentality, would have their sequel in the abrupt and harsh design of *Easy Rider*.

Of course he could stop taking photographs after this: the drama of the film had made this redundant. In the film images, the tough style of the photographs had become intensi-fied. Likewise, in reverse order, the experience of the film *Colors* had made him observant of the expressive use of graffiti in com-munications among various street gangs; and what could not be expressed by him in the film served as the basis for a new series of paintings. In other words, those films are not interruptions of Hopper's artistic activity but rather *links* that unify and inter-connect parts of the whole. This is how I gradually came to the conclusion that, within the context of his work as an artist, we had to find a place for the important films, rather than vice ver-sa. Actually, therefore, we should regard *Easy Rider* as a paint-ing, a polyptych, and not as an interruption of Dennis Hopper's work as a painter. That has become the theme of this exhibition in Amsterdam: looking at the entire oeuvre from the perspective of an ongoing, consistent design and treatment of material.

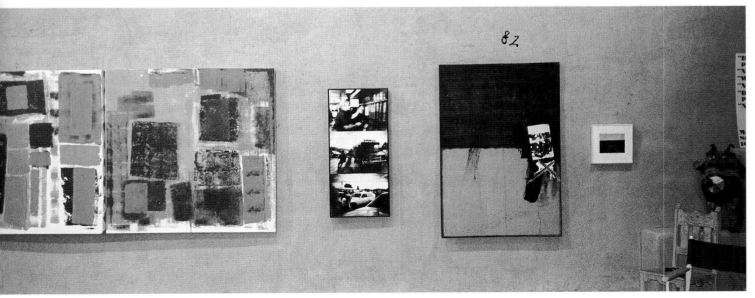

In our conversations Hopper always spoke about his art–and about the making of art in general–with singular and moving affection. I acquired the impression that he often missed the making of art, the contemplative character of this. In the day-to-day run of things, his life is mainly taken up with the bothers of the film world and of being Dennis Hopper. The making of art takes place during certain periods, in time that he must set aside for this. If he is unable to be doing this, the making of art is consequently present, in a peculiar way, as an absence in his life–and thus as a longing as well. From the way in which this matter continually arose in our talks, it could be gathered that the making of art has a central place in his life. At the center is that quiet concentration, the artist being alone with himself at that moment, away from the turbulence of public life. This is also how he spoke about his studio in Taos, New Mexico–as though it were a hiding place, far from what had once, long ago, overtaken his vocation as an artist.

It could be that I am painting a slightly romanticized picture of this. Of course Dennis Hopper is also an actor and filmmaker in heart and soul. In my opinion, those activities are

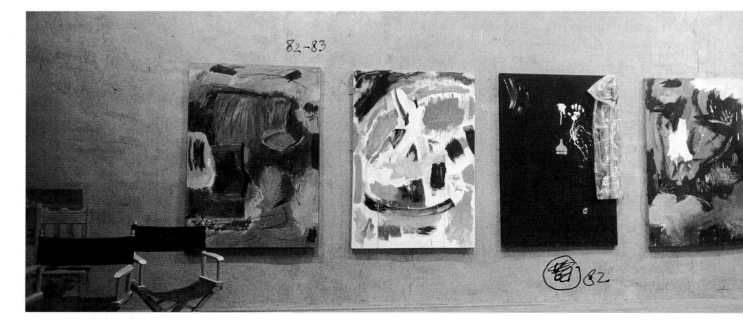

inextricably linked with that same artistry at the actual center of his existence. But the outside world places him in two worlds. That is the reality which makes him and his work restless and hectic and which has led to that oeuvre of abruptly alternating phases and moments. When we, Jan Hein Sassen and I, spent several days at the studio in Taos, I noticed in the various things from various periods, all standing there jumbled together, that these may well have been produced so abruptly and impulsively that they actually had not yet reached a state of calm. That was a strange experience: to see works there, some of them still from the early sixties, which were restlessly awaiting their completion and a place.

The studio is a former movie theater from the 1930s, built in adobe in the Mexican style, just outside Taos along the road to Santa Fe. Little has been renovated in the high space;

the front rows of seats are still standing. No painter's materials were lying around; work is done only at intervals. The newest paintings that were there dated from 1994. Standing diagonally in the space was a white partition on wheels. That is the wall on which he paints. There was a large painting which Hopper referred to as being unfinished: a large canvas with two bizarre (Rorschach-like) forms, painted robustly in white with frayed edges, onto a ground of light brown. Dangling on a string in the upper part, like a kind of insect, was an odd doll of Mexican origin. For one reason or another, the completion of this painting had been interrupted–possibly since 1994, as it appeared to be part of the group of paintings from that year. That group has a collective title: *Morocco*–eight or nine paintings in various sizes, into which abstract patterns and marks have been incorporated (manipulated, enlarged, rearranged, clarified), these having been seen by Hopper on weathered old walls in Morocco and photographed. They are clear and lyrical and gentle paintings; as we looked at them quietly, Hopper mentioned his fondness for Richard Diebenkorn; that connection was indeed discernible.

But I should like to attempt to find out how the mechanism of making art works with an artist who, unlike the one who spends day after day in his studio, roams back and forth among different disciplines and media and who therefore works in the midst of interruptions.

In the *Morocco* series there were still two other paintings in which active and almost decorative squiggles and tendrils of paint had been applied to the soft brown surface, but these *hovered* in the space of the image surface. Their character was therefore very different from that of the much more intense and obstinate forms in the expressionist paintings from 1982-83. But the two white forms in that unfinished painting hanging on the partition did lean in that direction–and I think that that painting is therefore unfinished. It escaped the formal and chromatic style or tone that Hopper had in mind at that point; it became unmanageable. For after the *Morocco* series had begun as a result of detailed observations of Moroccan walls, Hopper continued in the wake of the paintings, in 1995-97, with large photographs of walls in Italy. For some time, these benign and intimate aesthetics prevailed in the working process.

Dennis Hopper talks about the studio as an inviting and sheltered place. But he can never be there for long: his film work takes him away from it. When he produces art, it is usually in brief periods of concentrated working–as on a precise project, with purpose, until the theme is completed or exhausted. The groups of works that make up his oeuvre as an artist lie relatively far apart. They seem to be isolated eruptions of fanatic creativity. Because work from most of the groups has remained in Taos, we went to the studio there–in order to gain a

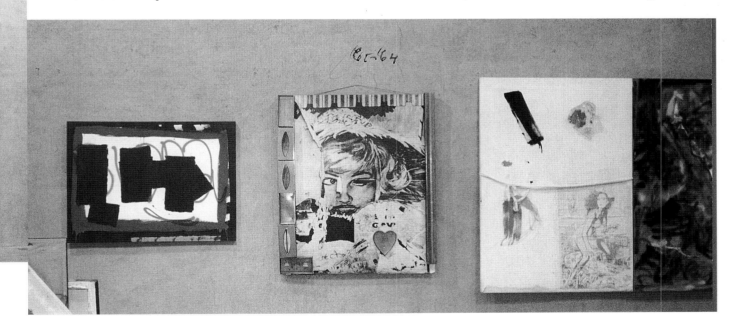

The brown painting with the white forms and the Mexican doll seemed, in comparison to the finished *Morocco* series, to be heading in a different direction. The white forms were displaying impulsively expressionistic behavior, also in the abrupt manner of painting. With that the painting was reverting somewhat to the tendency of several other paintings and assemblages from 1982-83 that were leaning against the wall in the studio. Those were highly expressionistic in character: fragments of vehement brush movements in all directions, compactly brought together on top of each other, explosive and colorful. With two others, predominantly black, the surface had become suspenseful and restless by means of fast lashes of paint.

general perspective. I wanted see what links existed among the various moments and what memories they kept of each other. But first we should map out the course of production.

Due to the fire in Bel Air in 1961, only a few of the early works remain: several photomontages which, in terms of the image concept, relate to the photographs from the sixties. I know of one earlier painting, from 1955. Hopper was nineteen years old at the time. It is a small work, a 'matter painting' like those that were being made in Europe then (by Dubuffet, Tapiès): a compact and heavy surface, a dark reddish brown. I can see the young artist in Kansas, intently stirring the paint around, mixing it with sand or some other grit, and then discovering

something that was not there yet. This, in any case, is how an artist is supposed to work: plodding away into the unknown. And so in 1955 he was onto something. But during that same year he also played in his first films–in one of these, *Rebel without a Cause*, together with James Dean, with whom he appeared a year later in *Giant*. How did those experiences relate to such a laborious matter painting? Pop art was also beginning to blossom during those years: Rauschenberg, Jasper Johns, in Los Angeles Ed Kienholz and Wallace Berman, who primarily made assemblages. Assemblage, or the construction of heavy surfaces with a complex materiality, was a form of making art that definitely appealed to the matter painter Hopper. The work that has survived from the early sixties shows the marks of that attraction. It involves combinations of assemblage with photographs and with painting, direct and raw, that is to say

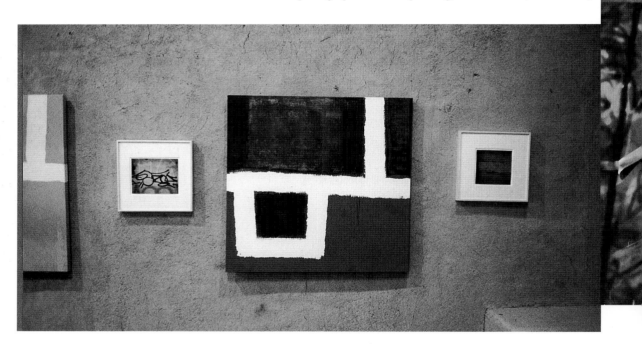

without the refinement of developed aesthetics. Also in the production of paintings from the early eighties, when he returns to this after a long interval and after the three big films (*Easy Rider, The Last Movie, Out of the Blue*), the assemblage technique plays an essential role.

That the photographs from the sixties are so different from other photography from that time–though the themes bear a superficial resemblance to the photographs of Peter Frank or Garry Winogrand or even the old master Walker Evans–is precisely due to the fact that they have been conceived with the eye of the assemblage-maker and painter. Contrary to my experience in the past, I am now struck more and more by the strangely *unphotographic* quality of Hopper's photographs. In general, for instance, the motifs are set down sharply, observed from a close perspective in a generally shallow, confined space. The background is often filled with additional motifs such as posters, inscriptions, ornaments: an abundance of *other things and marks* that come into view in the vicinity of the main motif. There is hardly room for airiness and atmosphere. The photographs are dark and compact in form. In their visual aspect,

they have a dense weight which is reminiscent of assemblage.

After *Easy Rider*, the film that changed his life and made him a character, he made no art for years, at most sporadically or when an opportunity arose. Then, in 1982-83, there came the small, wild group of paintings and assemblages, expressionistic in character, to which I have referred earlier. But I also recall that small matter painting from 1955–and the nineteen-year-old artist's urge to discover and hold onto something that could help him in his progress. Following this, he must have worked hard between the acting jobs, as it is stated that almost three hundred paintings were lost in the Bel Air fire of 1961. The small matter painting looks as though it had been worked on for quite a long time. The few things from the

patience for this wasn't there. For that reason these paintings, which also hold all sorts of reflections from twenty years of American art, have a distinct and moving quality. They don't fit, but there they are: messy and obstinate, each work unto itself. Compared to these, the later *Morocco* series from 1994 and the *Graffiti* series from 1991-92 were constructed and developed with much more control. But the basis for those two later series was laid in the session from 1982-83, where an experience was rediscovered. The *Graffiti* paintings were made ten years later: a group of works in which the graffiti of gangs, visually supported by broadly painted rectangular frames, are raised to monumental motifs. There is a certain gloriousness about the paintings, as if they were altarpieces. The project of painting them followed the

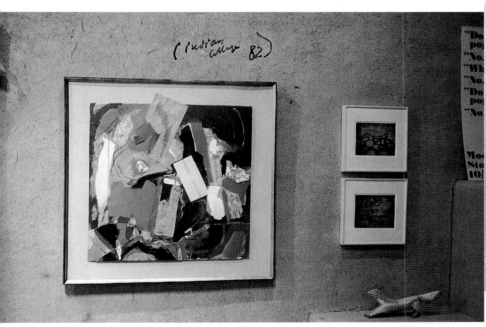 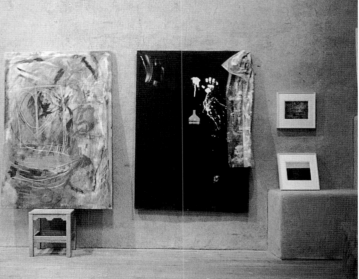

years 1961-1964 still standing in Taos make a much more nonchalant impression: they are put together more loosely and impulsively–entirely in accordance with the assemblage technique that would start to play a role in Hopper's art.

With the exception of the photographs, the making of art had come to a halt then. Photography is a less time-consuming medium than painting, easier to fit into the increasing film work; but in photography Hopper may also have sensed a more precise control once he had found his own form; photographs may have been a more effective way for him to arrive at what he wanted to show. Then, in 1969, came *Easy Rider* and, after that, other films. *Out of the Blue* was shot in 1980. It was a difficult phase in Hopper's life. Therefore, as I see it, the work from 1982-83 was made with a new beginning in mind. When I look at those paintings, at their obsessive hecticness and at their sloppiness, I have the impression that the artist was in a hurry. Once more, after all those years, he wanted to put into practice all that he still knew from the old days: the movements of the hand and the controlling keenness of the eye. He wanted to know whether the inspiration, as they say, was still there, whether he was still capable of doing it. The paintings have a reckless appearance; they're vehement, they're scarcely finished–as though the

1988 film *Colors*, directed by Hopper. Large stills of dramatic moments in the film, printed on linen in black-and-white, have been linked with the paintings just as in the predella and panels of a medieval altarpiece, where we see depictions of important moments from the lives of saints. At the same time or prior to these paintings, small and medium-sized polaroid photographs with very intense and vivid close-ups of the graffiti were also produced.

Hopper's most recent project, just finished, is a series of life-size *Wall Assemblages*: reproduced lengths of fencing or wall, complete with bars in front of windows and heavily bolted doors, all of this painted to some extent in the manner of the broad, solemn *Graffiti* paintings. As before, and in fact always, forms and impulses from earlier work come together in these works: in his oeuvre, we have seen, things carry each other further in this way. With these assemblages the large photographs of walls, with their enigmatic marks and signs, have also played a role of course–a project from the second half of the nineties is still going on. But the experiences related to the making of *Colors* were probably more important impulses: the role, in that film, of the grim and terrifying urban landscape in certain parts of Los Angeles. That landscape has become a determining

protagonist in the film–just as the landscape and the movement through it played leading roles in *Easy Rider*.

Much of the work that has been discussed here stood in the studio in Taos. In the days before, I had seen other work in Los Angeles, at Hopper's house and at different places in the city. In Taos we were able to hang all sorts of works easily and quickly, and in different sequences, on the soft walls of adobe. We spent two days carrying out these exercises. One combination after the other was tried out and studied and discussed. We were looking for a Dennis Hopper exhibition that had not yet been made. An exhibition is a succession and combination of

objects which tell a story in their progress: object next to object, walls, and walls diagonally or directly across from each other, from room to room. I suspected that, in that ostensibly confused body of work, with its different media and interruptions, there was signature to be found–a specific command of form and material and a sustaining emotion. For this to be found, the works there in that studio had to be brought to a state of calm so that we could look at them carefully and patiently–just as one should be able to do in the exhibition. That was the simple and practical goal of the exercise in Taos. In those two days, the different things slowly found their places. They became comparable. Despite the interruptions, they proved to be related to each other. Then what I had been hoping to find also became clear: that *Easy Rider*, too, is a work of visual art with a specific place in Hopper's oeuvre. The montage of the film found its form, often long sequences that ultimately collide with each other, via the artist's experience with the technique of the assemblage; assemblage is the abrupt way in which fragments are linked with each other. Separate short frames and particular types of subsequences come from the compact photographs from the sixties. As the two main characters start out, a magnificent long ode to the landscape follows. This arises from the captivating suppleness of the film camera and from the manipulation of light and color. But when nearly abstract images and slow

divisions of the image by an uneven horizon of dark hills take shape in that sequence: that again is the eye of the painter whose visual control can be discerned, much later, in paintings from the *Morocco* and *Graffiti* series. Talent that happens to be in the eye is not easily lost. At the same time, the hallucinatingly dramatic shots from the graveyard scene were ultimately, with all of those majestically and abruptly shifting images, a discovery yielded by the technique of the film. More than ten years would go by before he would attempt anything like this, images almost beyond control, in the hectic paintings of 1982-83, his new beginning, then as a painter. *Easy Rider* is also the discovery of a landscape which scarcely had a visual form prior to this film.

After that it was unforgettable. To phrase reality in such a way and allow it to exist forever is the true role of the artist. Paintings and films and novels can, through the course of time, easily lose their social or political relevance–but never the persuasive power of their compelling form.

One afternoon we were driving through Los Angeles and wondering what, in terms of its physical presence, there actually was to see. In the old culture of Europe, a great many things have been beautiful for a long time. There, for the first time and in an unforgettable way, an artist once painted an idyllic little square in the shade of its cathedral. Because of that, all city squares have become beautiful. But here, said Hopper, we've just started. Here we're far away from that old culture; farther than this is almost impossible. When you see a little square like that, it has probably been rebuilt for a film. Here we've just begun to look at this city. Almost nothing has been discovered yet. Meanwhile, artists and photographers and filmmakers there are, like Hopper, formulating images of new and unsuspected beauty; and so there will be more and more to see in Los Angeles. That is inevitable. "There is nothing more ancient in my memory," wrote John Adams in 1802, "than the observation that arts, sciences and empire had always travelled westward. And in conversation it was always added, since I was a child, that their next leap would be over the Atlantic into America."

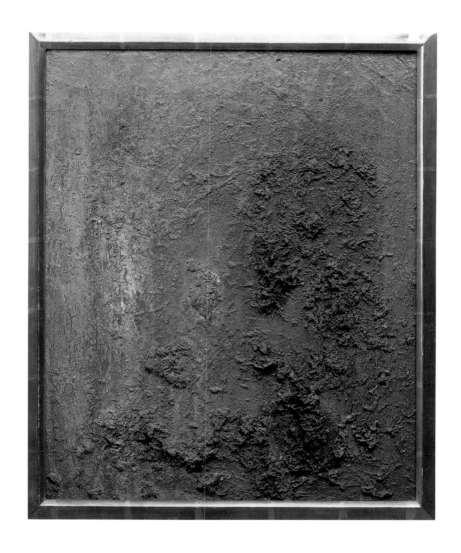

Untitled, 1955
oil on canvas
24 x 18 inches

Dennis Hopper/Marcel Duchamp
Hotel Green (Entrance), 1963
oil paint on wood panel
21 x 27 x 2.5 inches (framed)

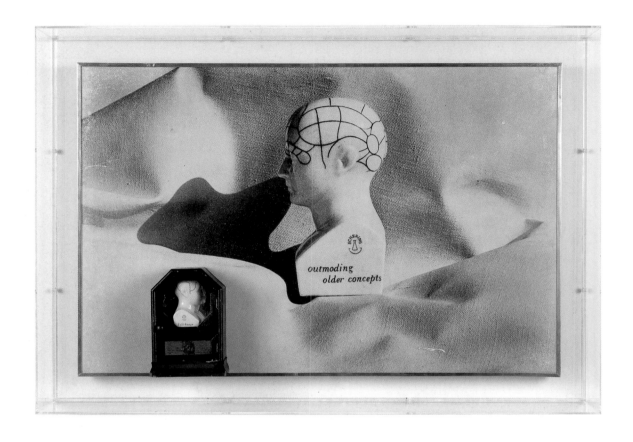

Wilhold the Mirror Up, 1961
photograph and assemblage
27 x 40 x 4 3/4 inches

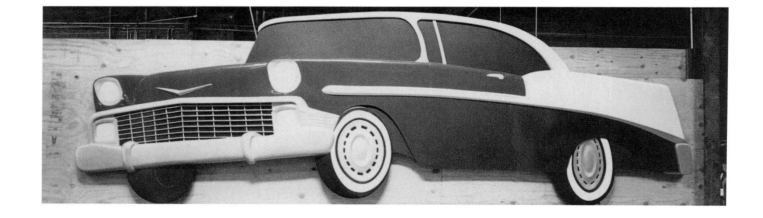

Untitled sculpture (The Chevy Piece, 1956), 1956/2000
large metal base relief sculpture with free standing gas signs
6 feet x 22 feet x 7 inches

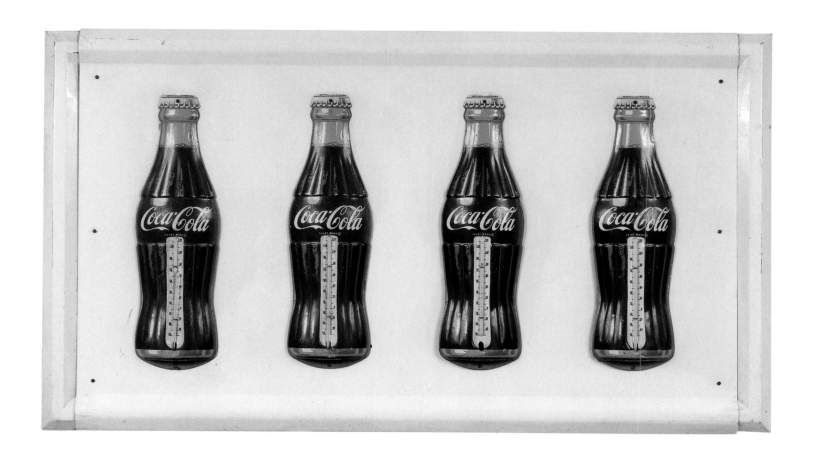

Coca Cola Sign, 1962
found object
tin sign with thermometers
24 x 36 x 3 inches

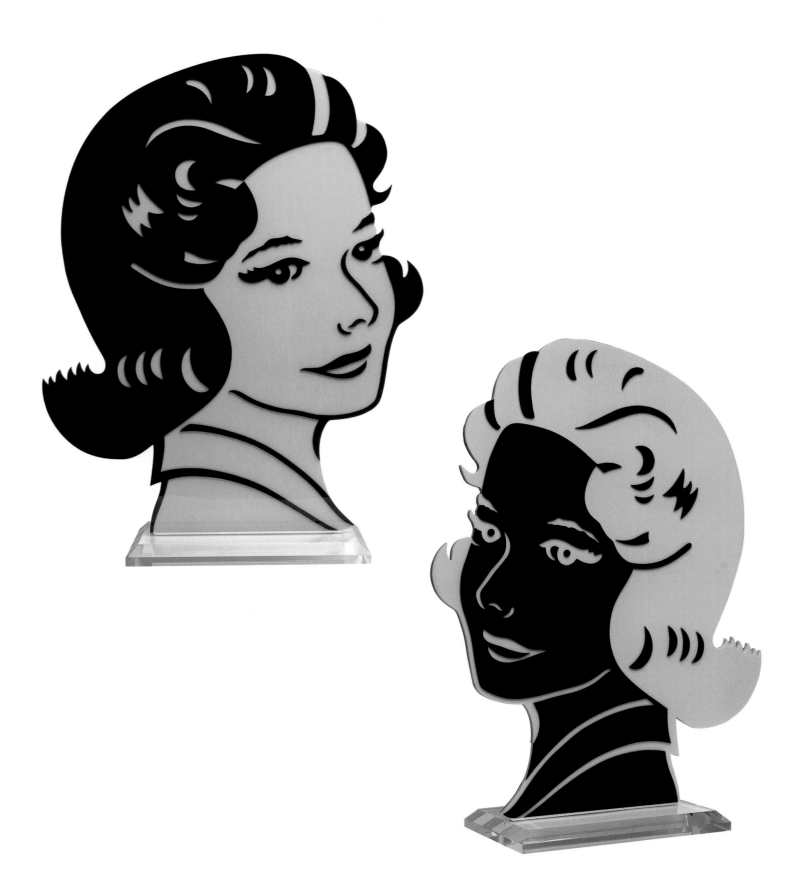

Draw Me and Win an Art Scholarship, 1964/2000
plexiglass
3 feet x 2 feet x 1 inch

This is Art (Marcel's Dilemma), 1997
neon sign
3 x 20.5 inches
Collection of Dallas Price, Los Angeles, CA

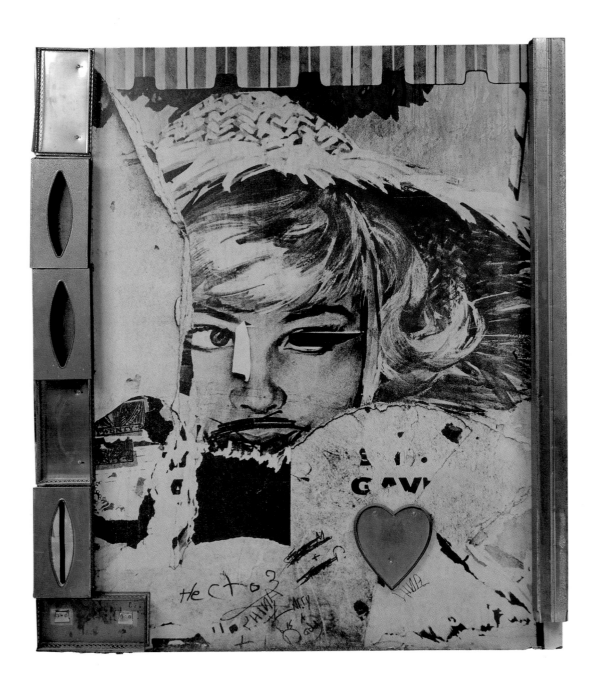

After the Fall, 1961-64
gelatin silver print with object
60 x 50 x 2 1/4 inches

Presto, 1961-64
photograph with object
25 x 91 x 1.5 inches

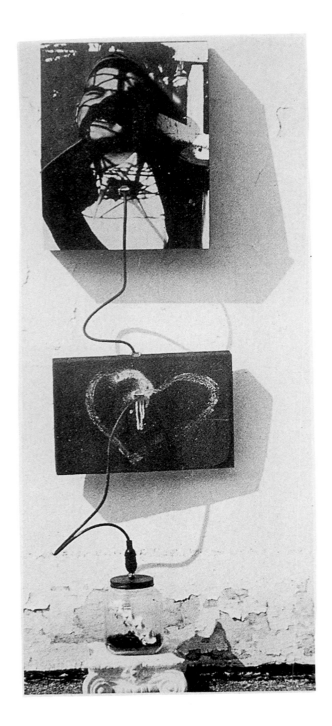

Jarred Connection, 1962/2000
glass jar, cement pedestal,
black electrical wire, metal clamp connectors,
electrical plugs
approx. 5.5 feet x 2 feet x 6 inches

Proof, 1963
woodblock, photograph and paint on board
47 x 35.5 inches

Chiaroscuro, 1963
gelatin silver print on aluminium
and wood mannequin heads
59 x 48 x 12 inches
Collection of University Art Museum, University of New Mexico

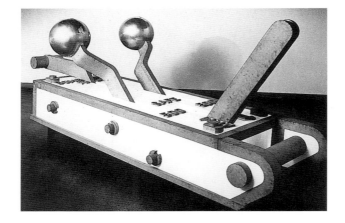

Bomb Drop, 1967/2000
plexiglass, stainless steel
approx. 4 x 11 x 4 feet

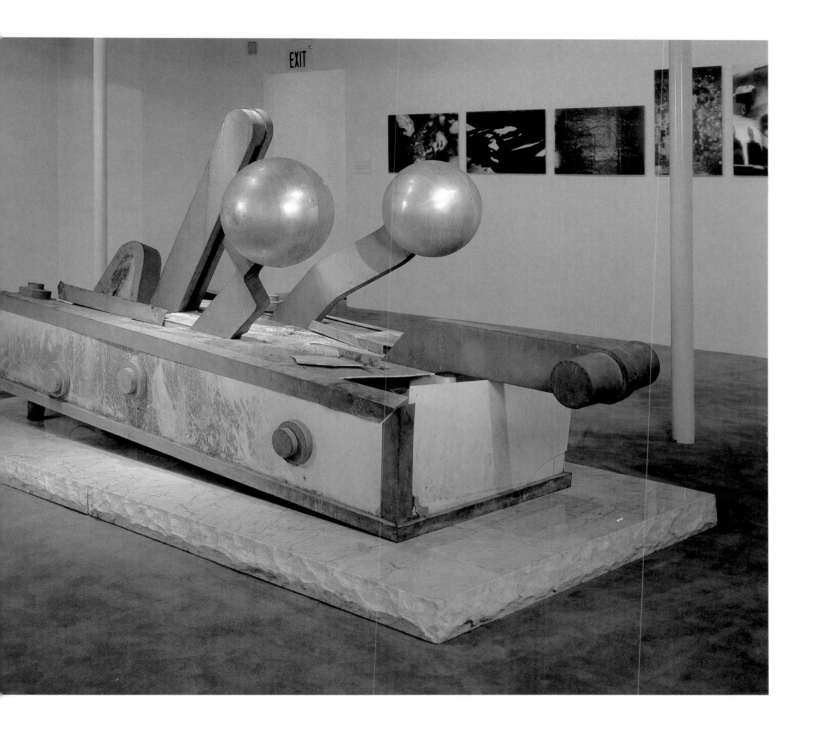

Bomb Drop, 1967-68
plexiglass, stainless steel, and neon
57 x 40.5 x 135 inches

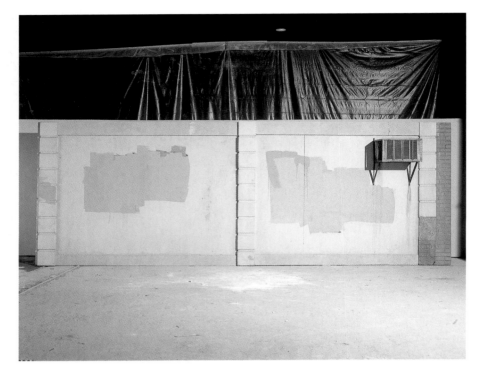

front view

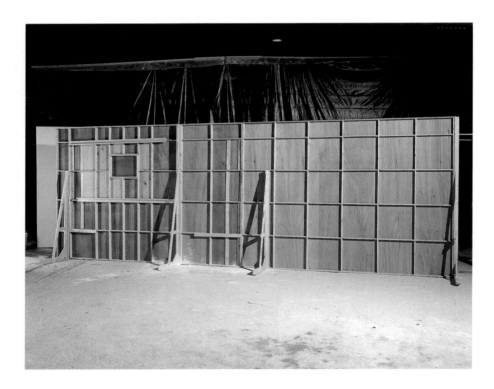

back view

Untitled #2, (Two stucco walls with concrete columns), 2000
mixed media
approx. 9 feet x 26 feet x 4.5 inches

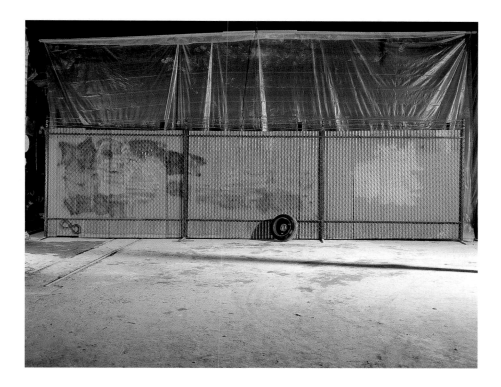

front view

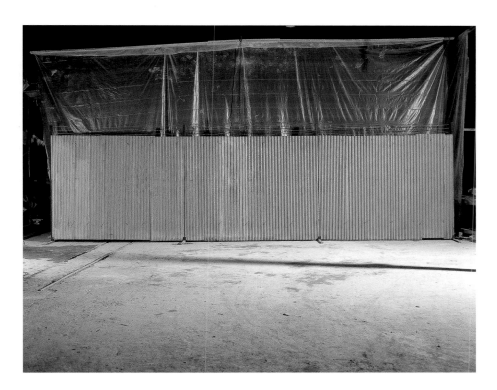

back view

Untitled #4 (Corrugated Fence), 2000
mixed media
approx. 8 feet x 34 feet x 5 inches

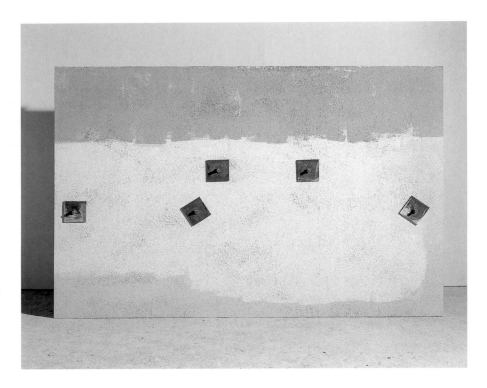

front view

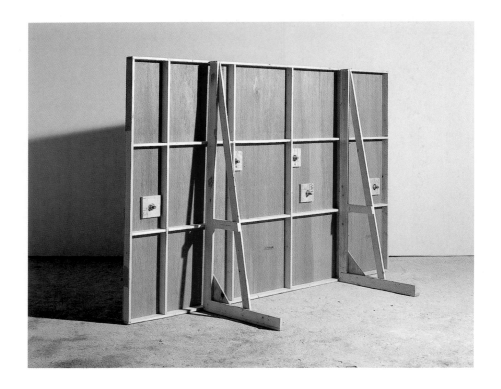

back view

Untitled #6, (Earthquake wall with plates), 2000
mixed media
6 feet x 9 feet x 4 inches

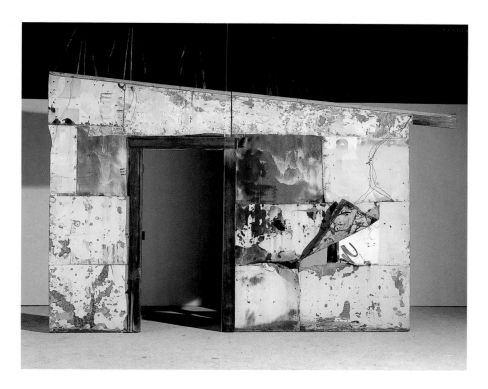

front view

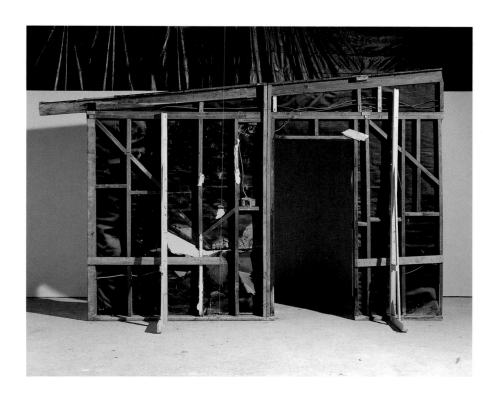

back view

Untitled #10, (Old metall wall), 2000
mixed media
9.6 feet x 13 inches x 7 inches

Untitled, (La Salsa Man), 2000 >
fiberglass, latex paint, steel,
and automotive clear coat
approx. 26 feet tall

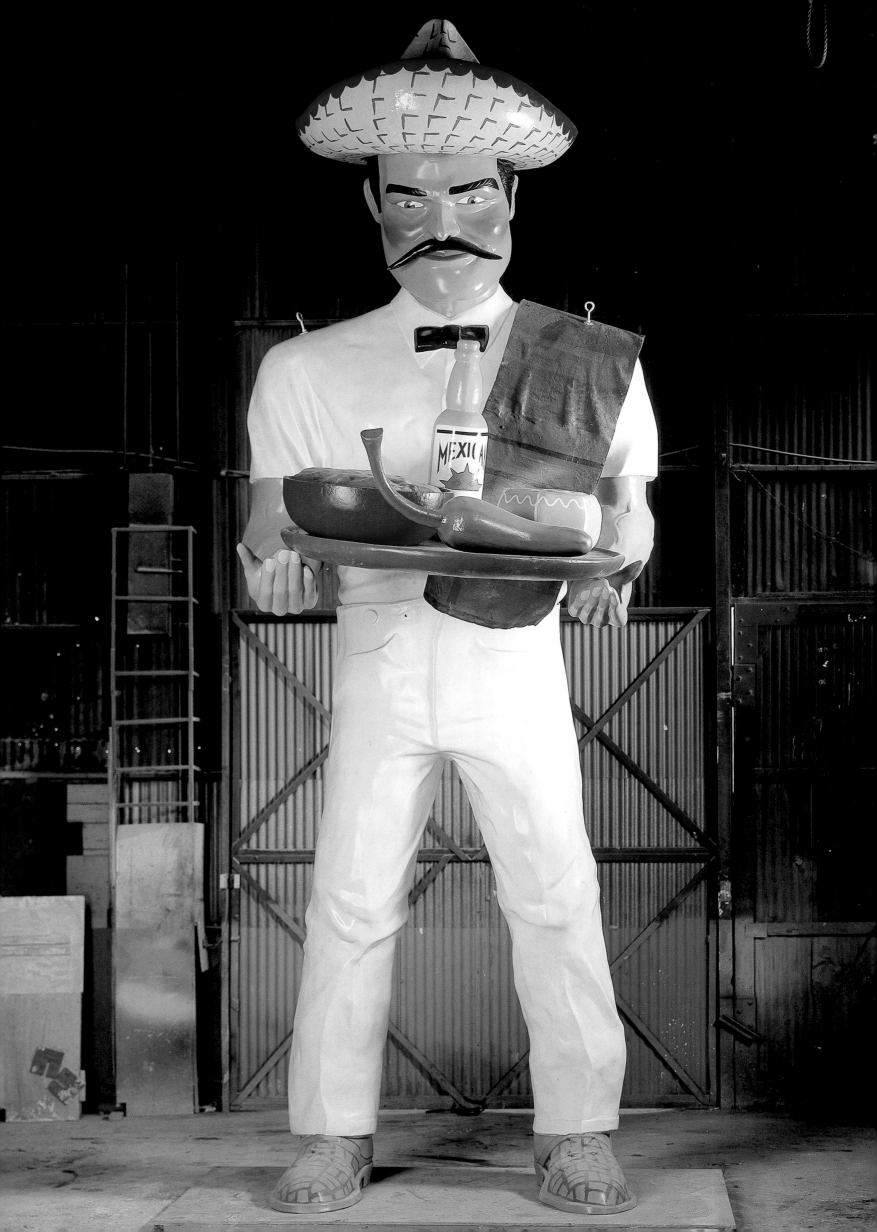

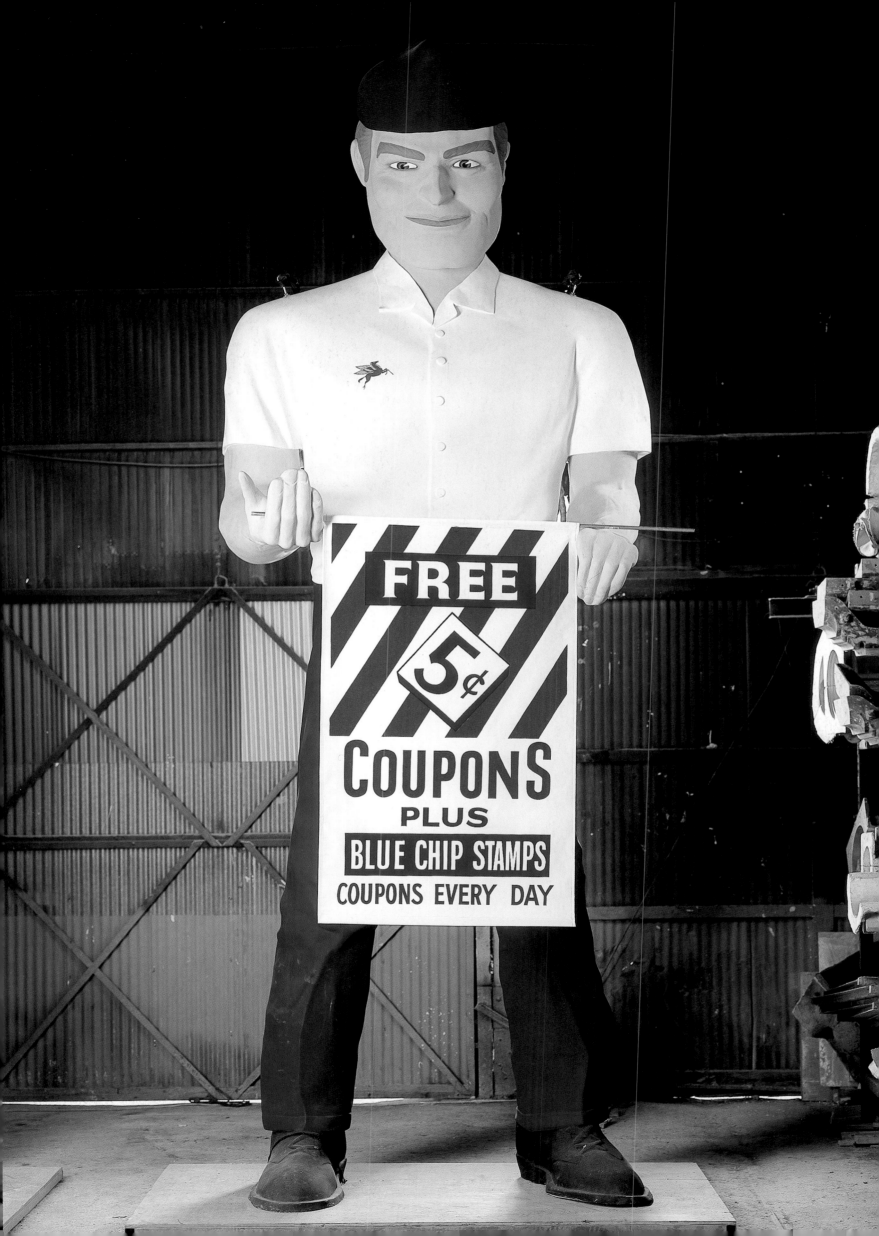

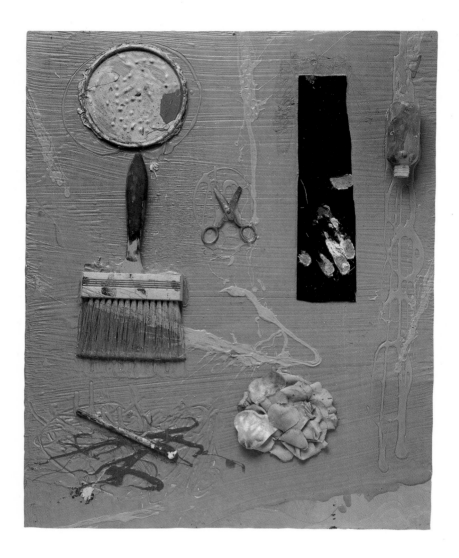

Untitled (with paint brush), 1961
oil on canvas
38 1/8 x 32 1/8 x 3 inches
Collection of Walter Hopps

< **Mobil Man**, 2000
 fiberglass, waterborn latex paint,
 steel, and automotive clear coat
 approx. 21 feet tall

Untitled (paint brush), 1982 >
acrylic on canvas with paint brush
72 x 48 x 1 3/4 inches

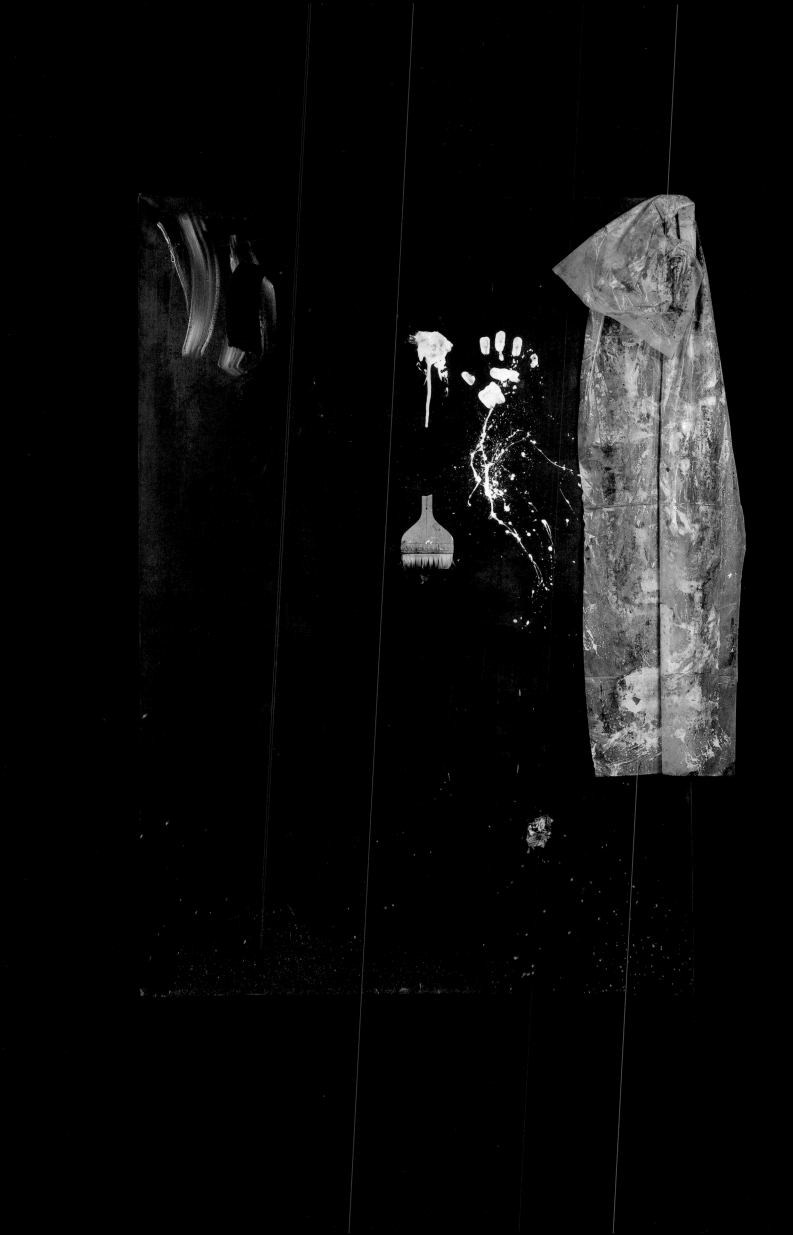

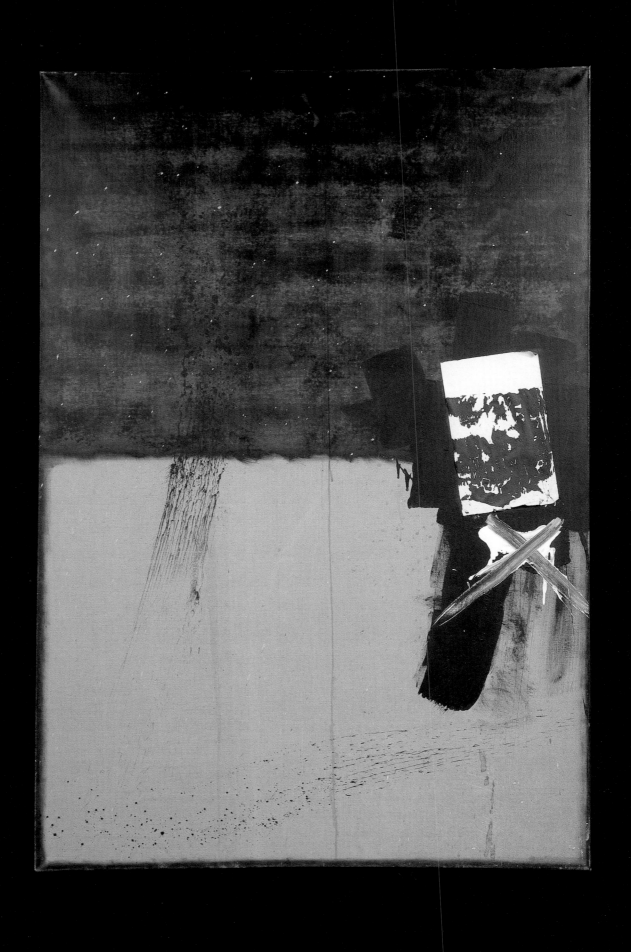

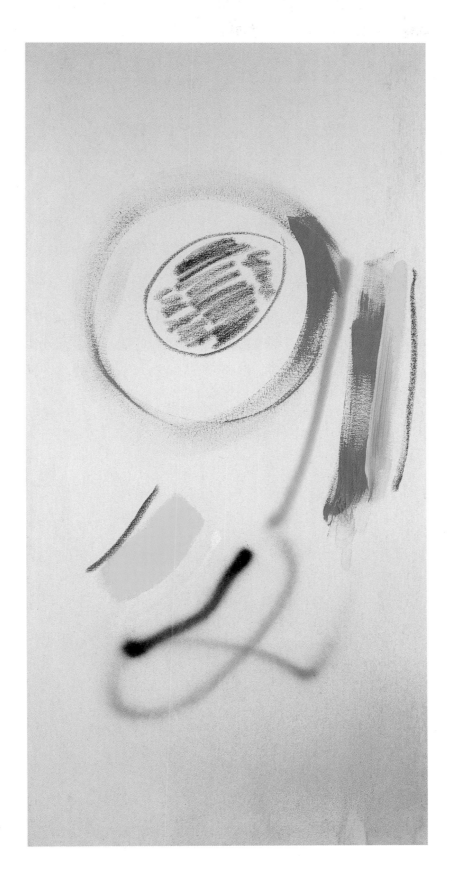

Untitled, 1982
acrylic and spray paint on canvas
approx. 6 x 3 feet

< **X-Xerox**, 1982
acrylic on canvas with verifax
approx. 6 x 4 feet

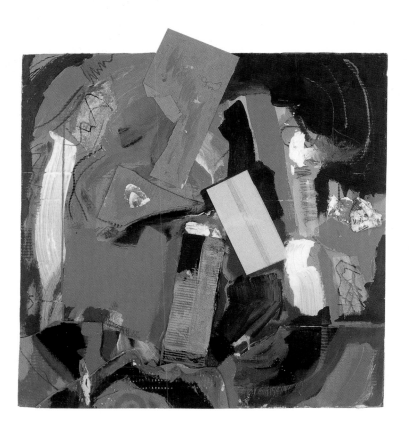

Untitled (Indian Collage), 1982
mixed media
approx. 4 x 4 feet (framed)

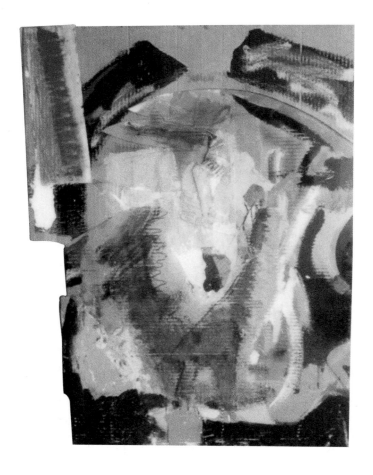

Untitled (Cardboard, Tin Indian), 1982
mixed media
approx. 48 x 36 x 3 inches

Untitled (Indian Collage), 1982
mixed media
approx. 4 x 3 feet (framed)

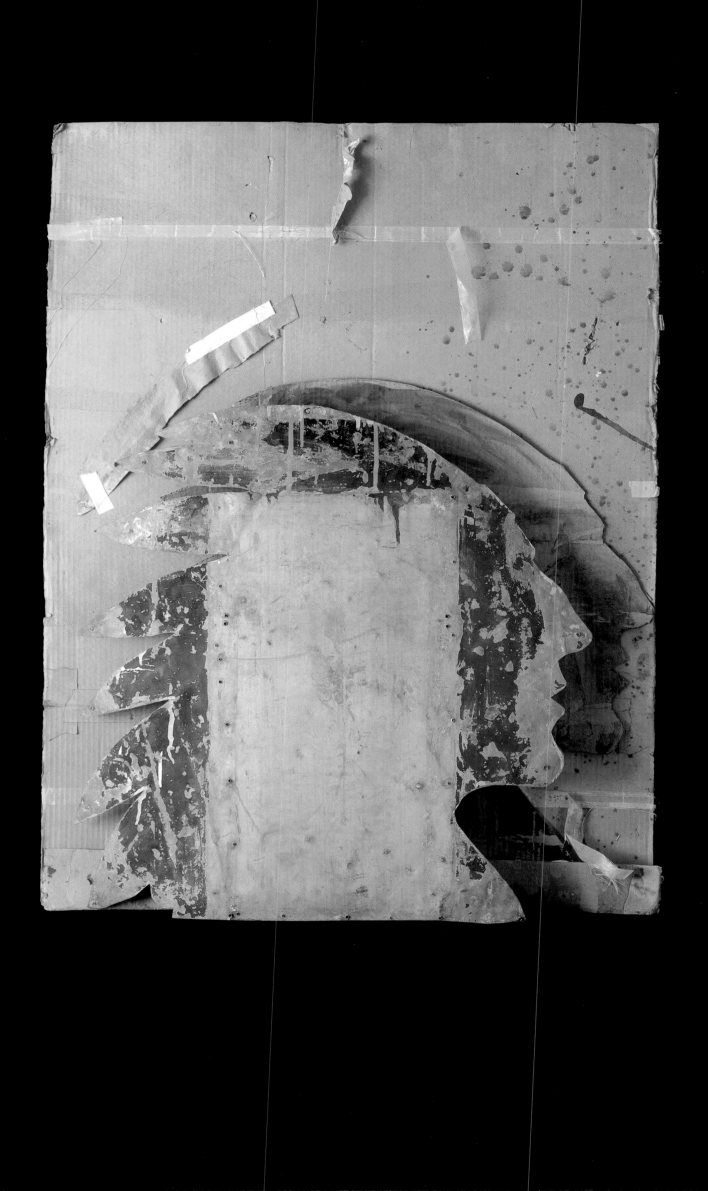

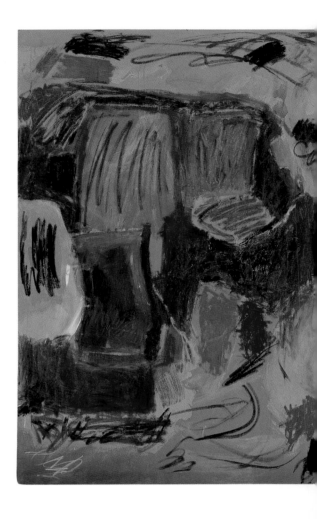

Killer Pussy (triptych), 1982-83
acrylic on canvas
72 x 158 x 1.5 inches

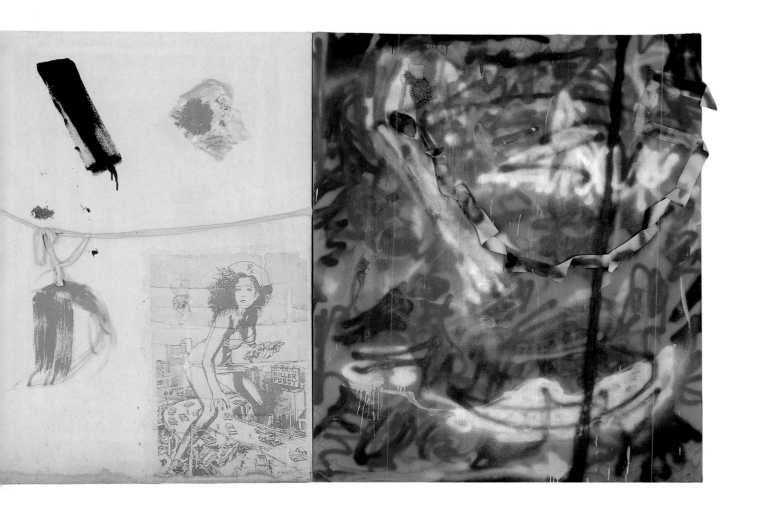

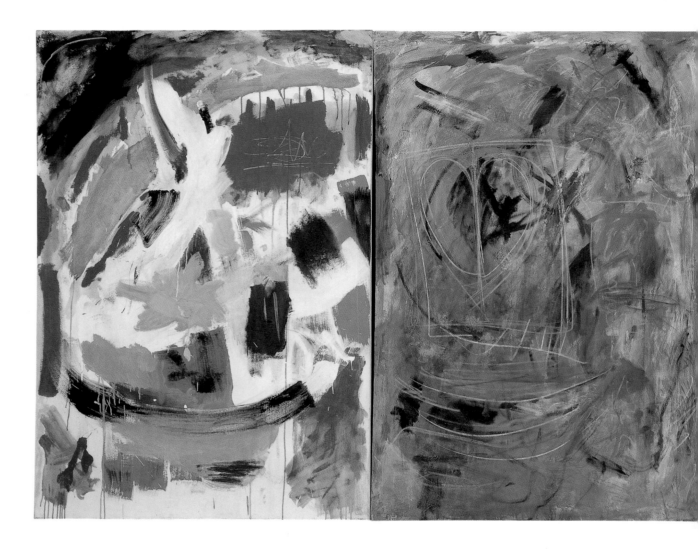

Untitled (triptych), 1982-83
acrylic on canvas
72 x 144 x 1.5 inches

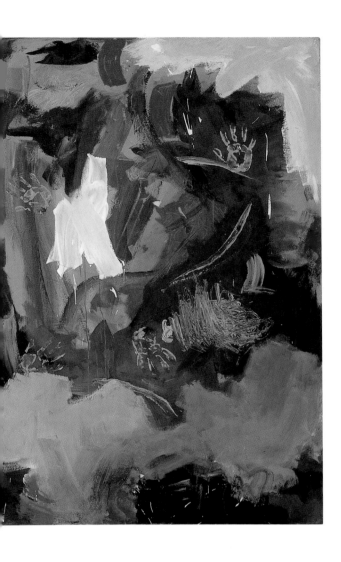

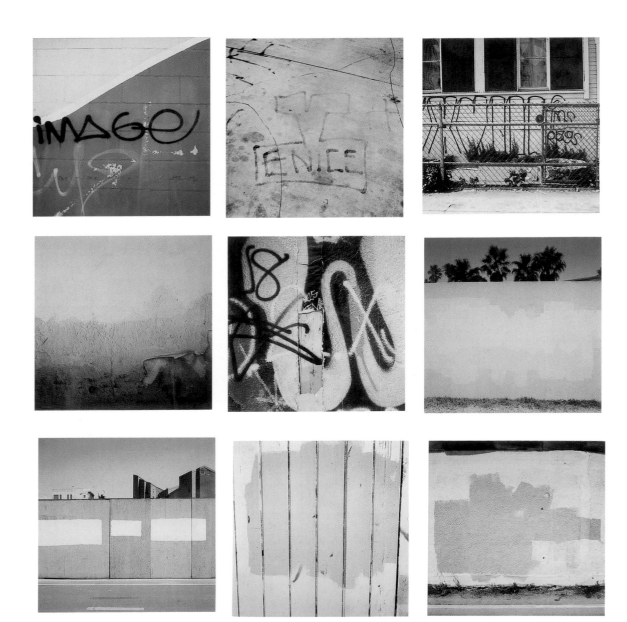

Untitled Polaroids, 1991
color photograph
16 x 16 x 2 inches (each)

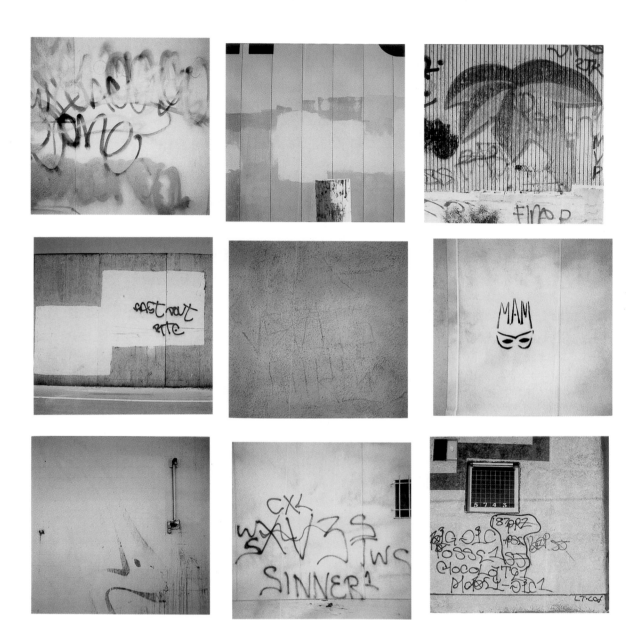

Untitled Polaroids, 1991
color photograph
16 x 16 x 2 inches (each)

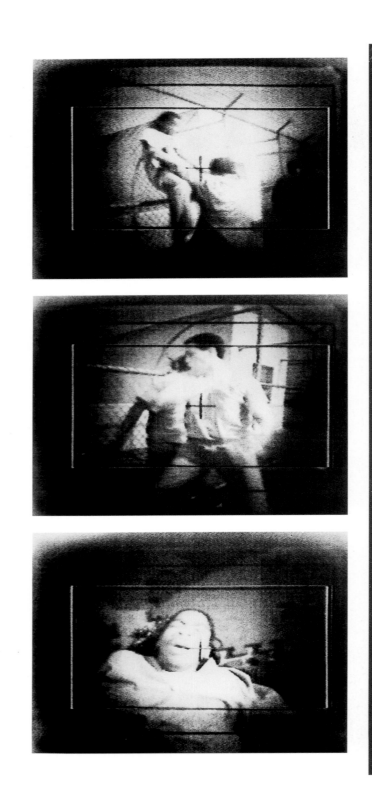

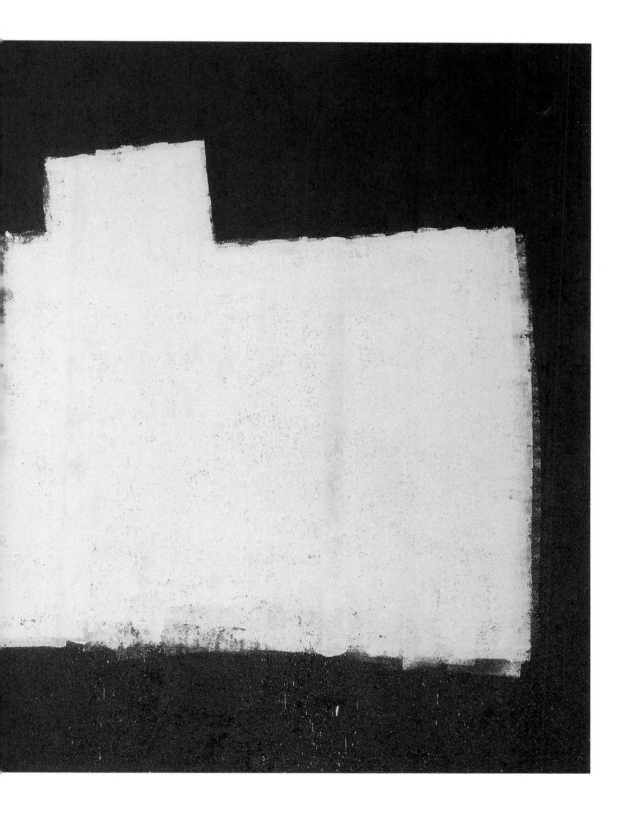

Beat, 1991
photo emulsion, acrylic, rolotex, spray paint on canvas
139 x 96 inches (overall)

Kill, 1992
photo emulsion, rolotex, spray paint on canvas
106 x 105 inches

Hood, 1992
photo emulsion, acrylic, rolotex, spray paint on canvas
110 x 70 inches

Untitled (One of Four Joiners), 1992
photo emulsion, acrylic, rolotex, spray paint on canvas
80 x 53 inches (two panels)

Torero (One of Four Joiners), 1992
photo emulsion, acrylic, rolotex, spray paint on canvas
80 x 53 inches (two panels)

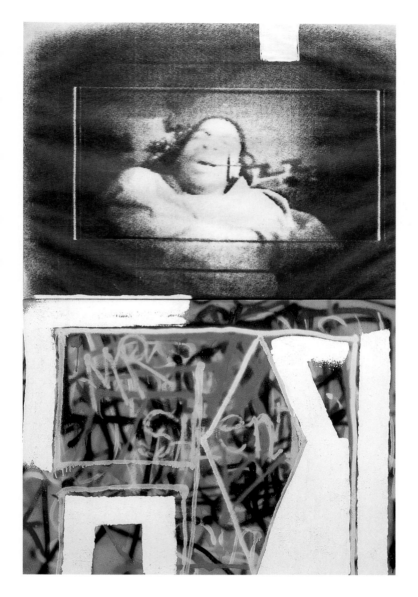 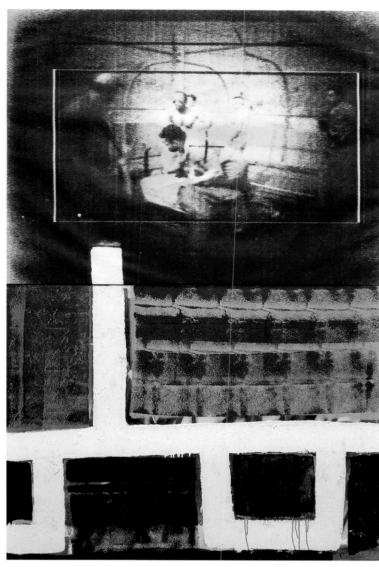

Untitled (One of Four Joiners), 1992
photo emulsion, acrylic, rolotex, spray paint on canvas
80 x 53 inches (two panels)

Untitled (One of Four Joiners), 1992
photo emulsion, acrylic, rolotex, spray paint on canvas
80 x 53 inches (two panels)

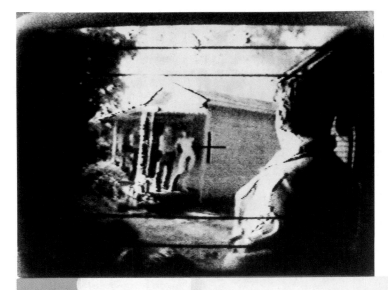

Cop, 1992
photo emulsion, acrylic, rolotex, spray paint on canvas
107 3/8 x 68 1/4 inches

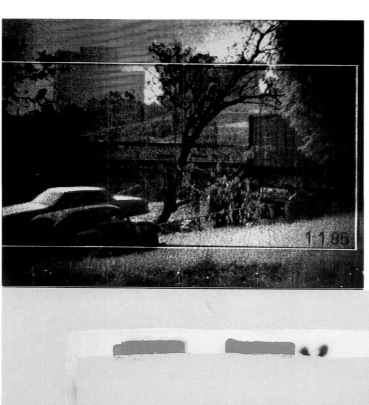

City, 1992
photo emulsion, rolotex, spray paint on canvas
108 x 68 inches

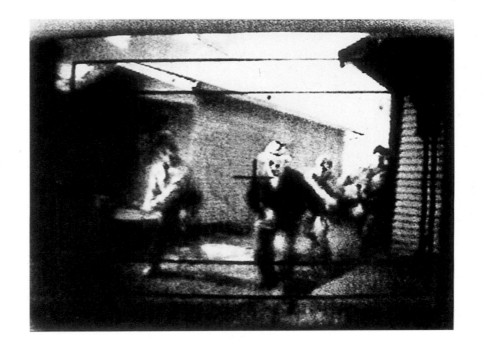

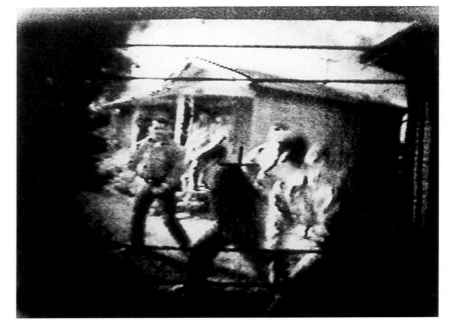

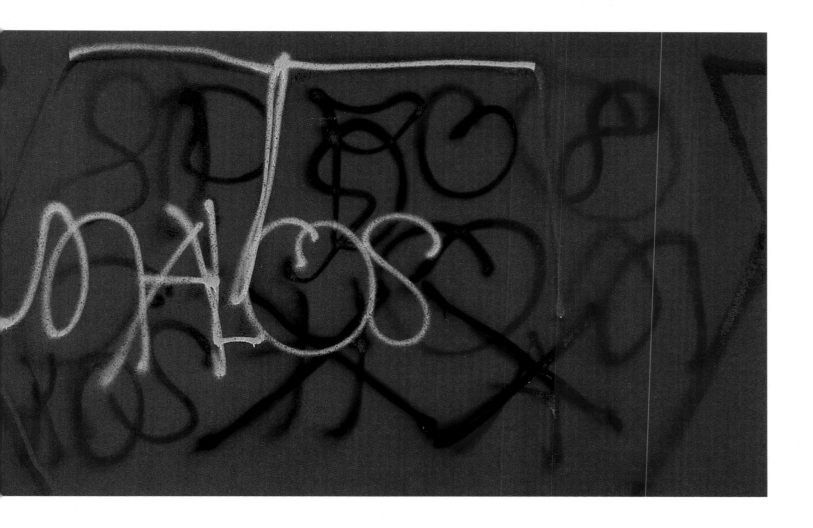

Heat, 1992
photo emulsion, acrylic, rolotex, spray paint on canvas
81 x 179 inches

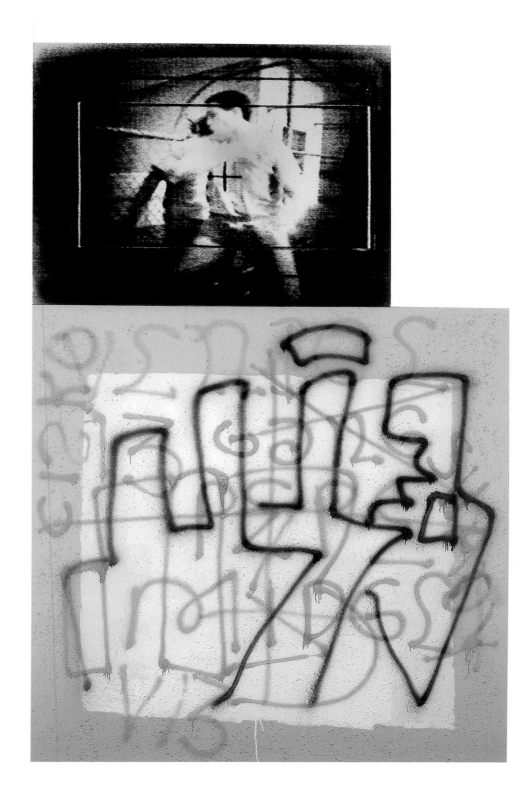

Via, 1992
photo emulsion, acrylic, rolotex, spray paint on canvas
110 x 70 inches

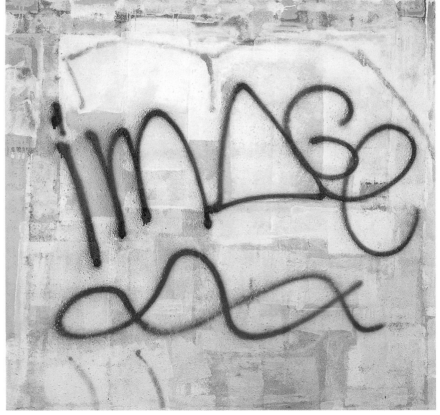

Off, 1992
photo emulsion, acrylic, rolotex, spray paint on canvas
104 x 64 inches

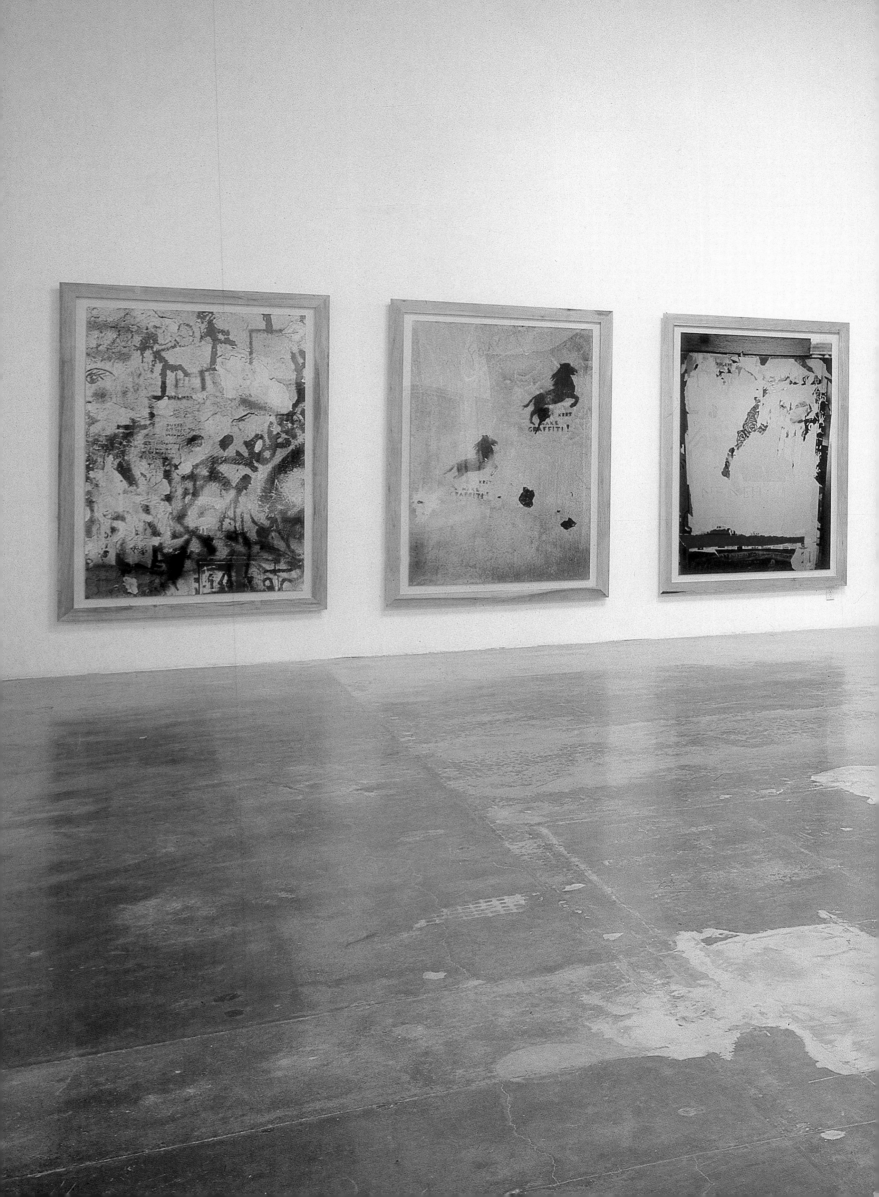

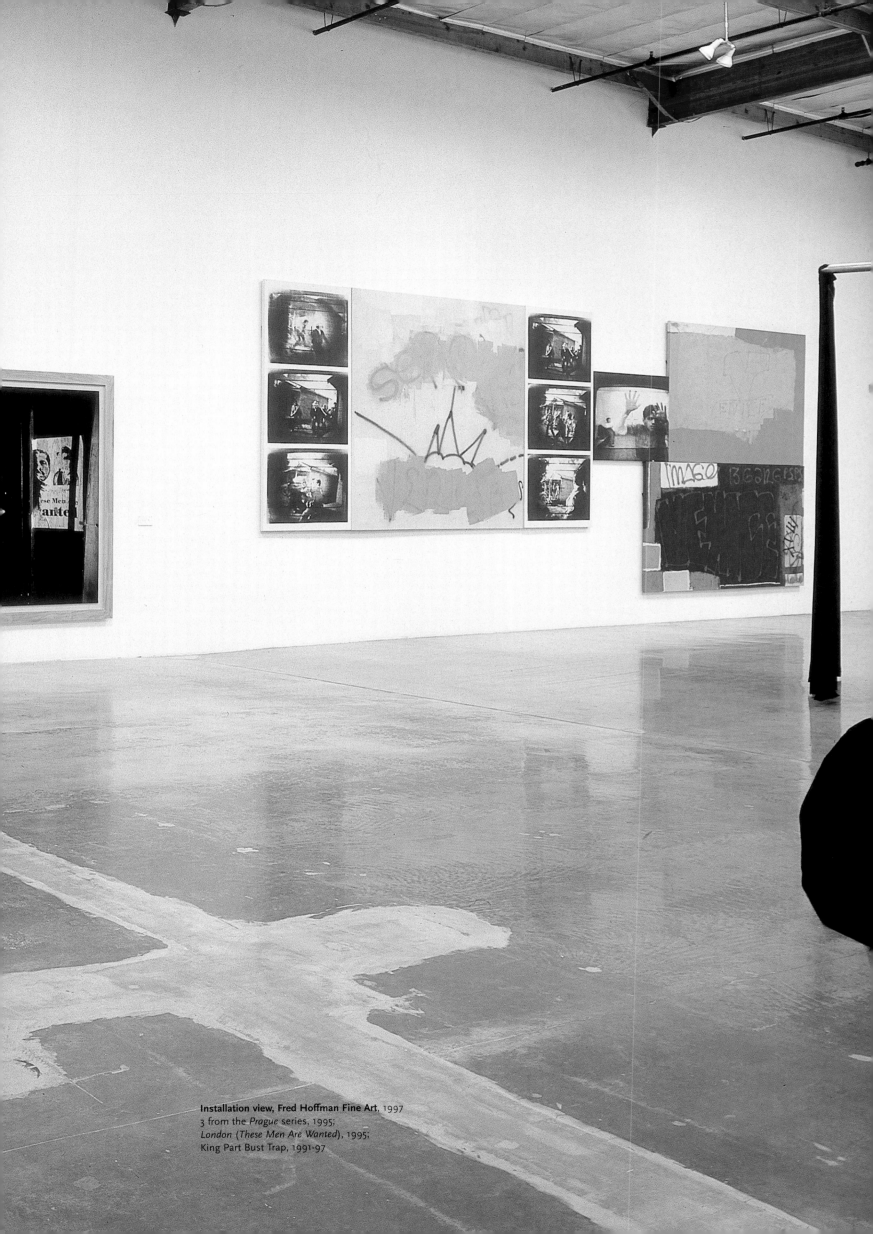

Installation view, Fred Hoffman Fine Art, 1997
3 from the *Prague* series, 1995;
London (These Men Are Wanted), 1995;
King Part Bust Trap, 1991-97

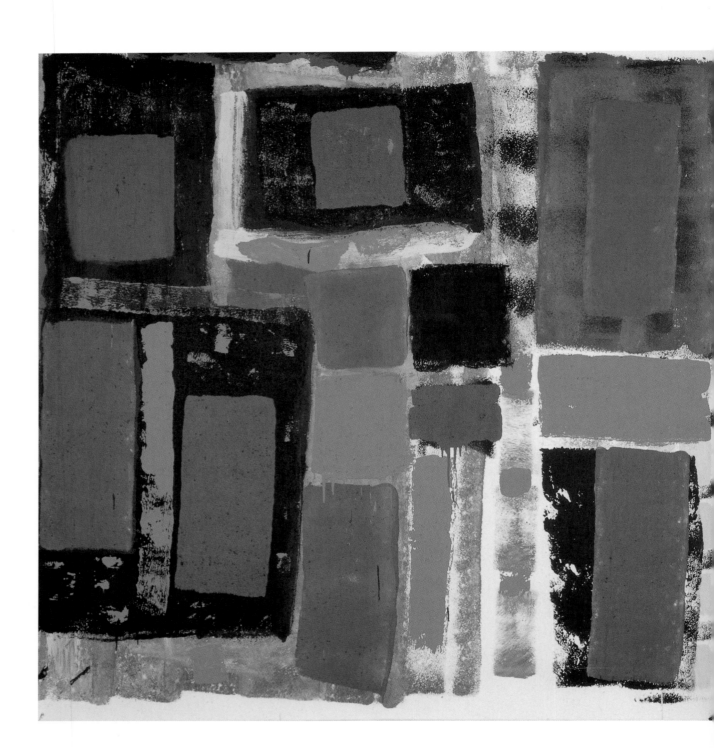

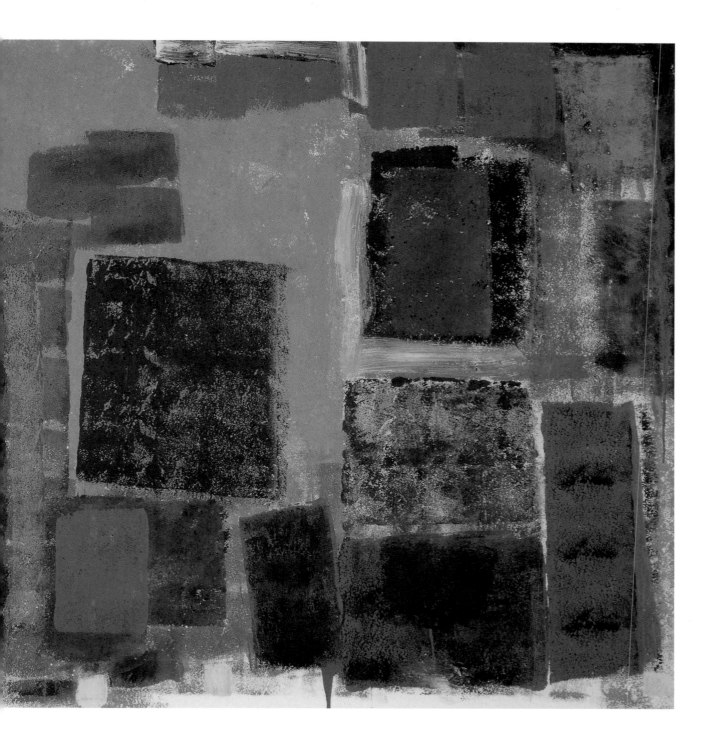

Morocco (diptych), 1994
acrylic on canvas
68 x 136 x 1.5 inches

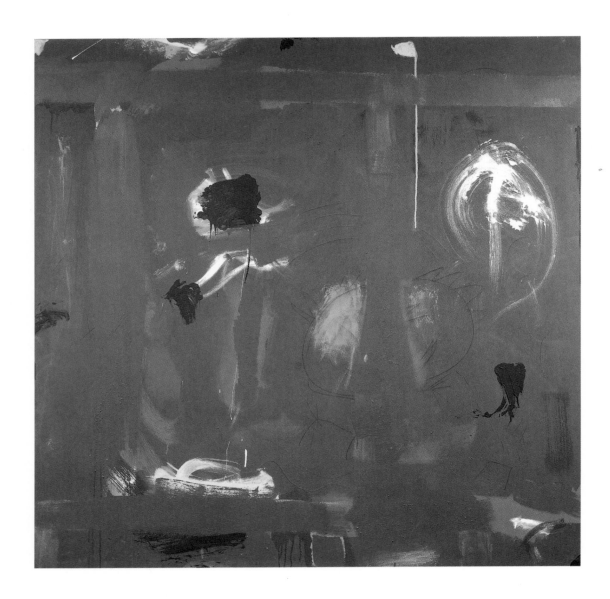

Morocco (grid), 1994
acrylic on canvas
40 x 53 x 1.5 inches

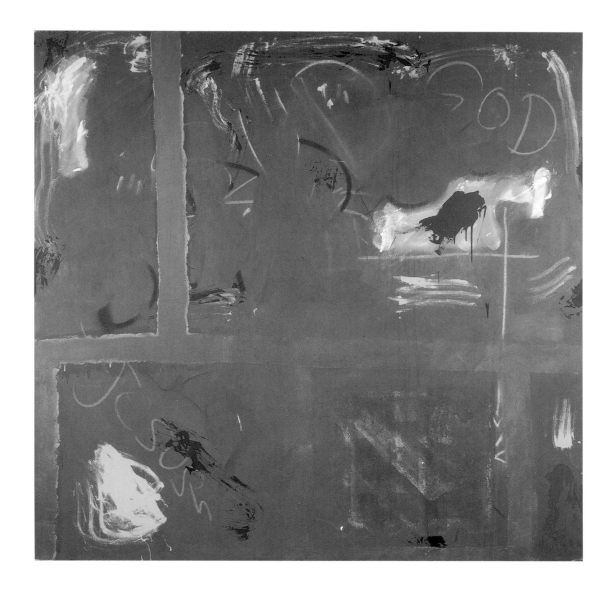

Morocco (brown grid), 1994
acrylic on canvas
70 x 70 x 1.5 inches

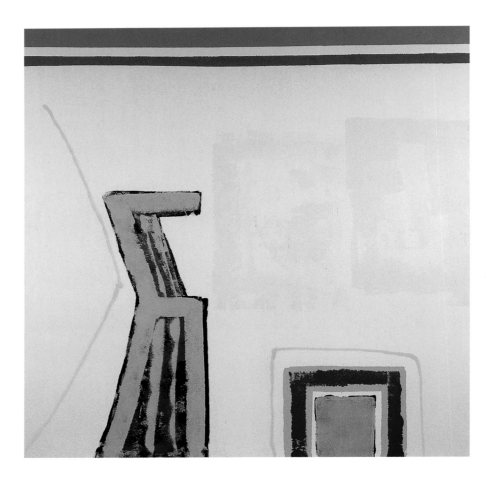

Morocco I, 1994
acrylic on canvas
70 x 70 x 1.5 inches

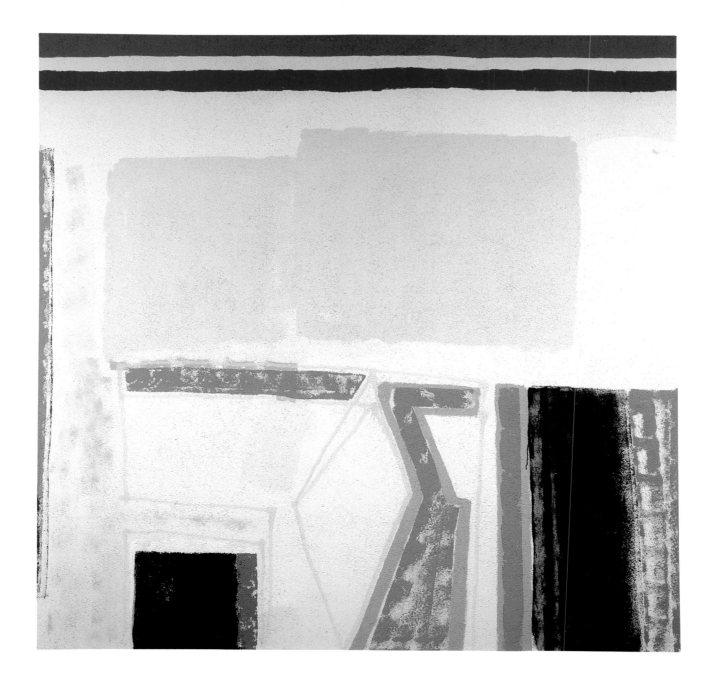

Morocco II, 1994
acrylic on canvas
96 x 96 x 1.5 inches

Untitled (Grid), 1994
acrylic on canvas
40 x 53 x 1.5 inches

Untitled (Morocco blue), 1994
acrylic on canvas
40 x 40 x 1.5 inches

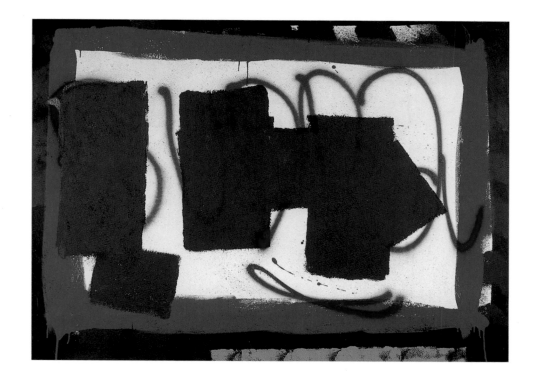

Untitled (Morocco Colors), 1994
acrylic on canvas
40 x 53 x 1.5 inches

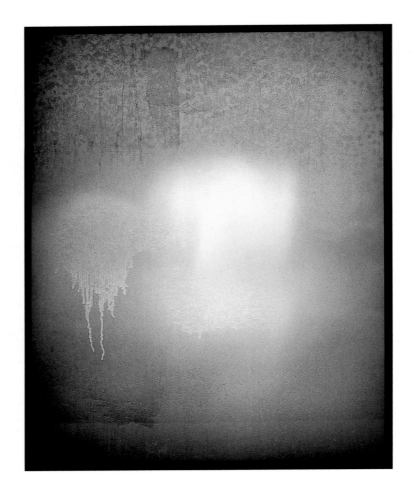

Amsterdam (Drip and Reflection), 1998
digital inkjet print transparency and lightbox
30 x 24 x 5 inches

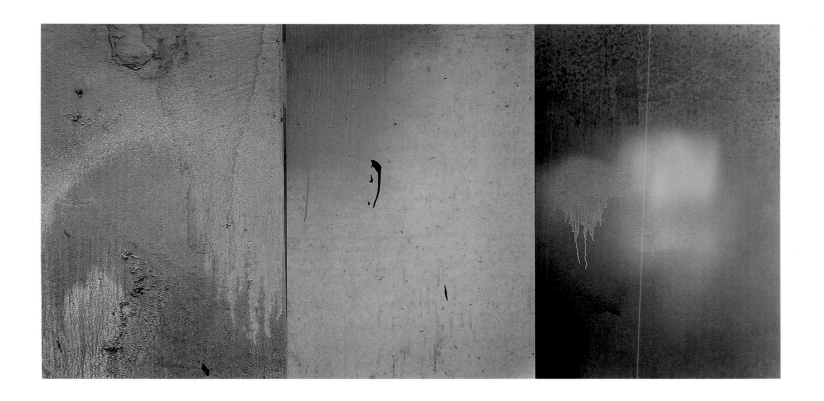

Untitled Triptych (Amsterdam), 1999
Ilfochrome on metal
27.5 x 47 3/8 x 1.5 inches (framed)

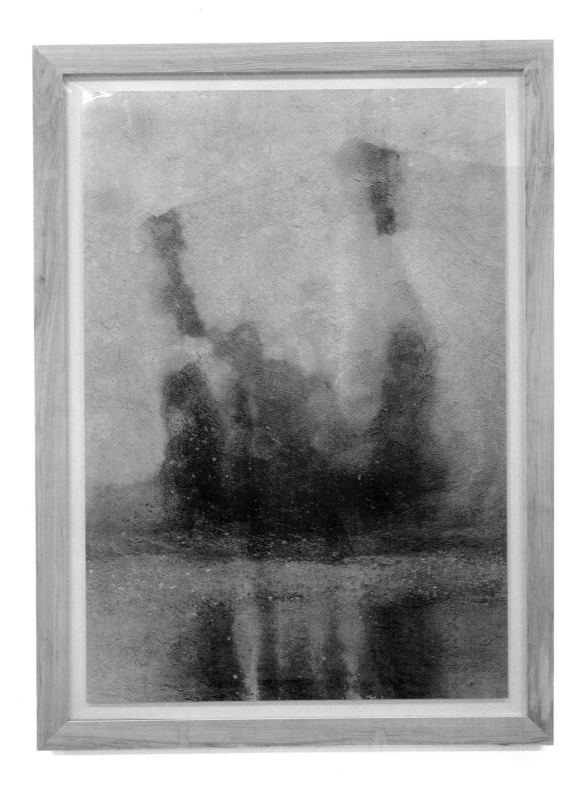

Florence (Stained Wall), 1996
Ilfocolor, ed./3
86.5 x 61.5 inches (framed)

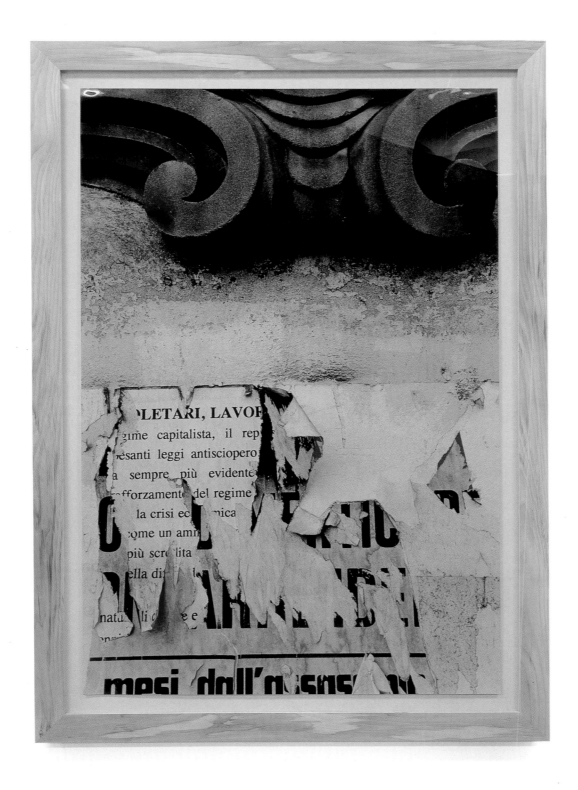

Florence (Capital), 1996
Ilfocolor on metal, ed./3
86.5 x 61.5 inches (framed)

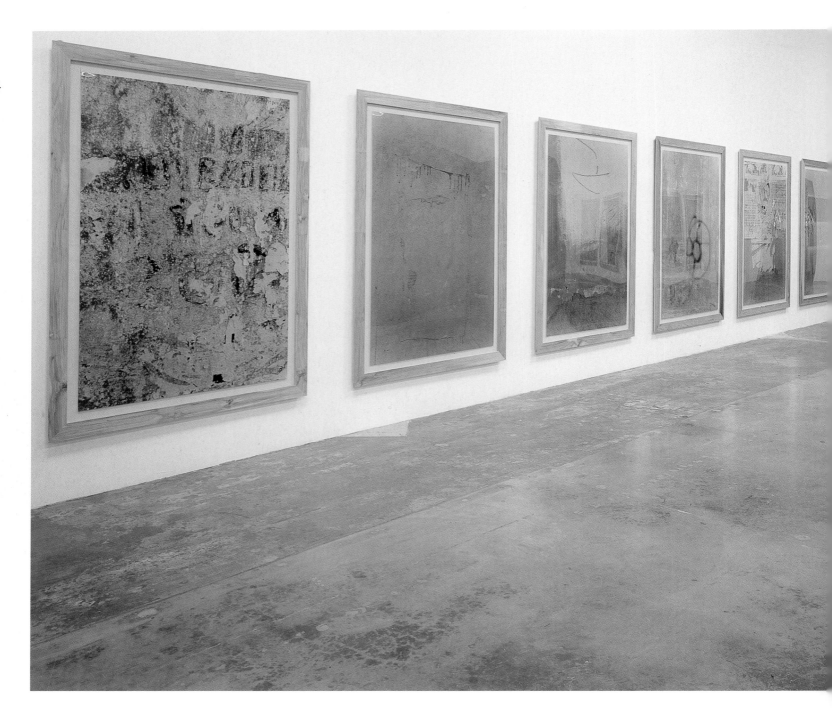

Installation view, Fred Hoffman Fine Art, 1997
Space (Painted walls outside SFMOMA), 1996
3 Ilfocolors, ed./3
86.5 x 61.5 inches each (framed)

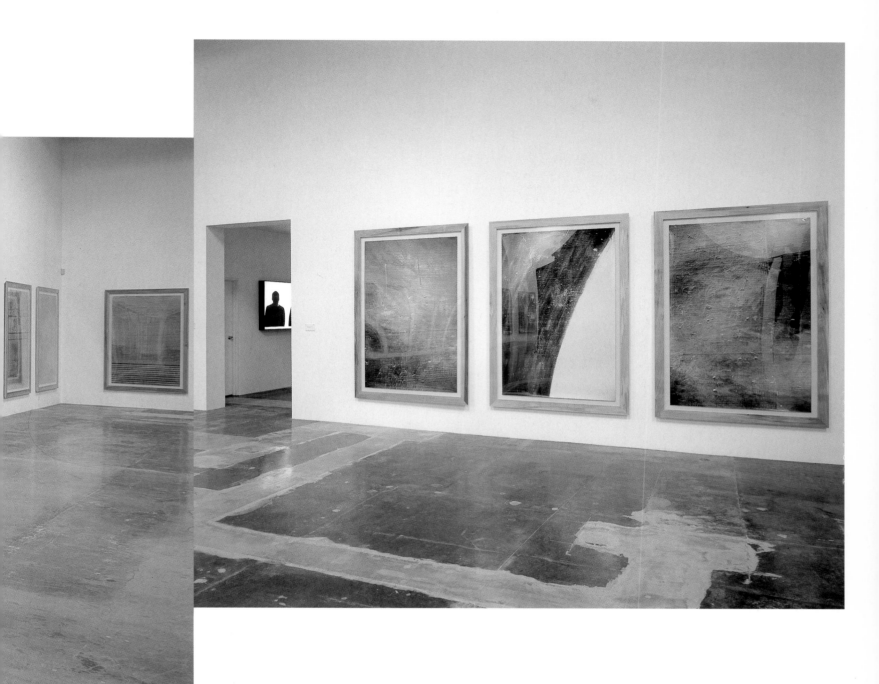

Installation view, Fred Hoffman Fine Art, 1997
9 from *Florence*, 1995-96;
and *Los Angeles (Green Door)*, 1995
86.5 x 61.5 inches each (framed)

along the western trail

jan hein sassen

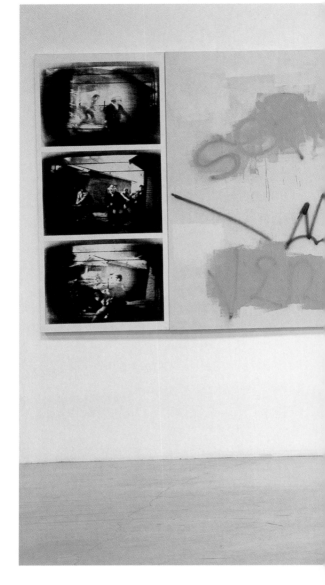

On our first visit to Dennis Hopper in Los Angeles, at the end of March (2000), he takes us to one of his studios, a vast space that was once part of the studio of abstract-expressionist painter Sam Francis. What initially strikes the eye is an artwork of generous proportions, consisting of three painted canvases and a number of smaller ones on which black-and-white photographs have been printed: *King Part Bust Trap* (1991-97). Originally these were three separate paintings, produced during the years 1991 and 1992. Each one is made up of large colorful surfaces on which graffiti has been sprayed and then entirely or partially painted away again. Printed onto the smaller black-and-white canvases are blurry photographs which, on closer examination, seem to be reworked film stills–dramatic scenes with lots of action.

In the film *Colors* (1988) directed by Dennis Hopper, two hardened LA cops– a fanatic younger one played by Sean Penn and an older, experienced policeman played by Robert Duval–take on two gangs who are at each other's throats. The gangs mark off their territories by spraying graffiti on walls. Painting over or spraying over this graffiti by the rival calls for revenge by the other gang. On a drive through Los Angeles one can see stretches of wall with such graffiti, painted over–or not–by rivalling gangs or by municipal workers. Several months later Hopper takes me to the warehouse space of a well-known billboard company in Los Angeles and shows me eight new paintings: enormous billboards painted by hand, at his request, by one of the last remaining masters of this profession. The surprise is that the images on the works are blow-ups of well-known photographs by Hopper from the sixties, such as *Billboard–Multi Image Woman's Face* (1961), *Torn Poster (Elect)* (1965): photographs of billboards enlarged once again into billboards.

This play of reality and illusion–with painting, photography trand, of course, film– has become Dennis Hopper's trademark. What Hopper did first, painting or acting, is no longer clear. When he received his first important role in *Rebel without a Cause* at the age of

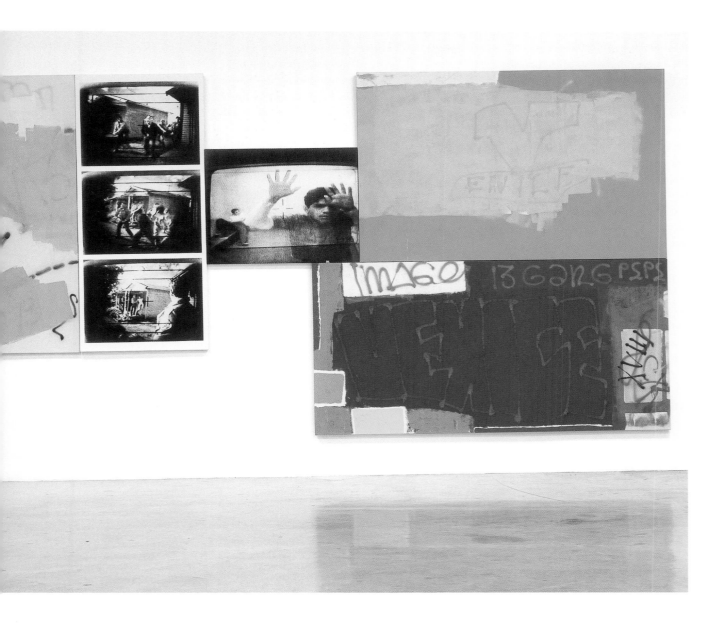

nineteen, he had already had some drawing and painting lessons in his home state Kansas, but it looked as though acting, for which he proved to have considerable talent and by which he wished to become famous, would take priority over his other creative talents for the time being. The acquaintance with James Dean, the leading actor in *Rebel without a Cause*, and their subsequent friendship was a crucial moment in his life. Not only a friend, Dean was a teacher and a model to Hopper. Both came from the country, the Midwest, both painted and had great plans for the future, boundless energy and creativity. But, above all, they were defiant, determined to break through the rigid Hollywood studio system and eventually direct films themselves: "It is hard to imagine now how young, vanguard Hollywood suffered and chafed in the years of the fifties and early sixties as compared to Italian and French New-Waves."[1] Jimmy Dean and Dennis Hopper would act together in only two films. On one of the last days of the filming of *Giant* (1956) Dean was killed in a car accident. The loss of this friend has profoundly influenced him throughout his entire life. But a number of decisive matters were learned from him. Dean taught Hopper how to act 'naturally': "Do things, don't show them. Stop the gestures...pretty soon it will be natural to you and you'll start going and the emotions will come to you if you leave yourself open to the moment-to-moment reality." What may have been just as important, though, was his advice to take up photography as a means of developing his artistic vision. "You gotta get out and take photographs. Learn about art, learn about literature, even if you want to be an actor." Since then he has taken thousands of photographs, for a long time only in black-and-white and full frame: "Cropping is not a luxury a director would have."

In Hopper's house in Venice there is a small, early painting from 1955–abstract, thickly applied, earth-tone colors–more reminiscent of a European 'matter' painting than one in

King Part Bust Trap, 1991-97
photo emulsion, acrylic, rolotex,
spray paint on canvas
126 1/4 x 337 x 1.5 inches

Billboard Factory >
**(multi image of a woman's
face)**, 2000
water based primer,
oil paint on vinyl
14 x 21.5 feet

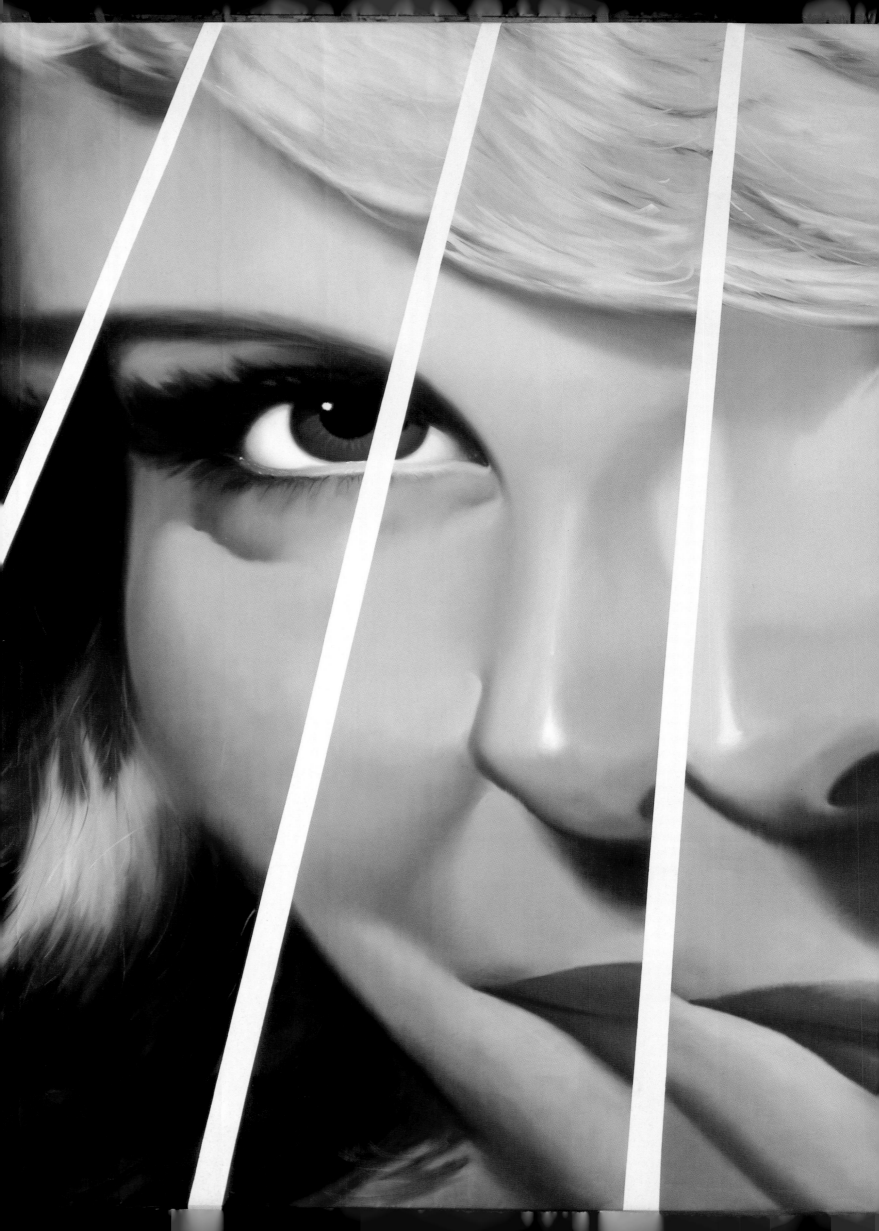

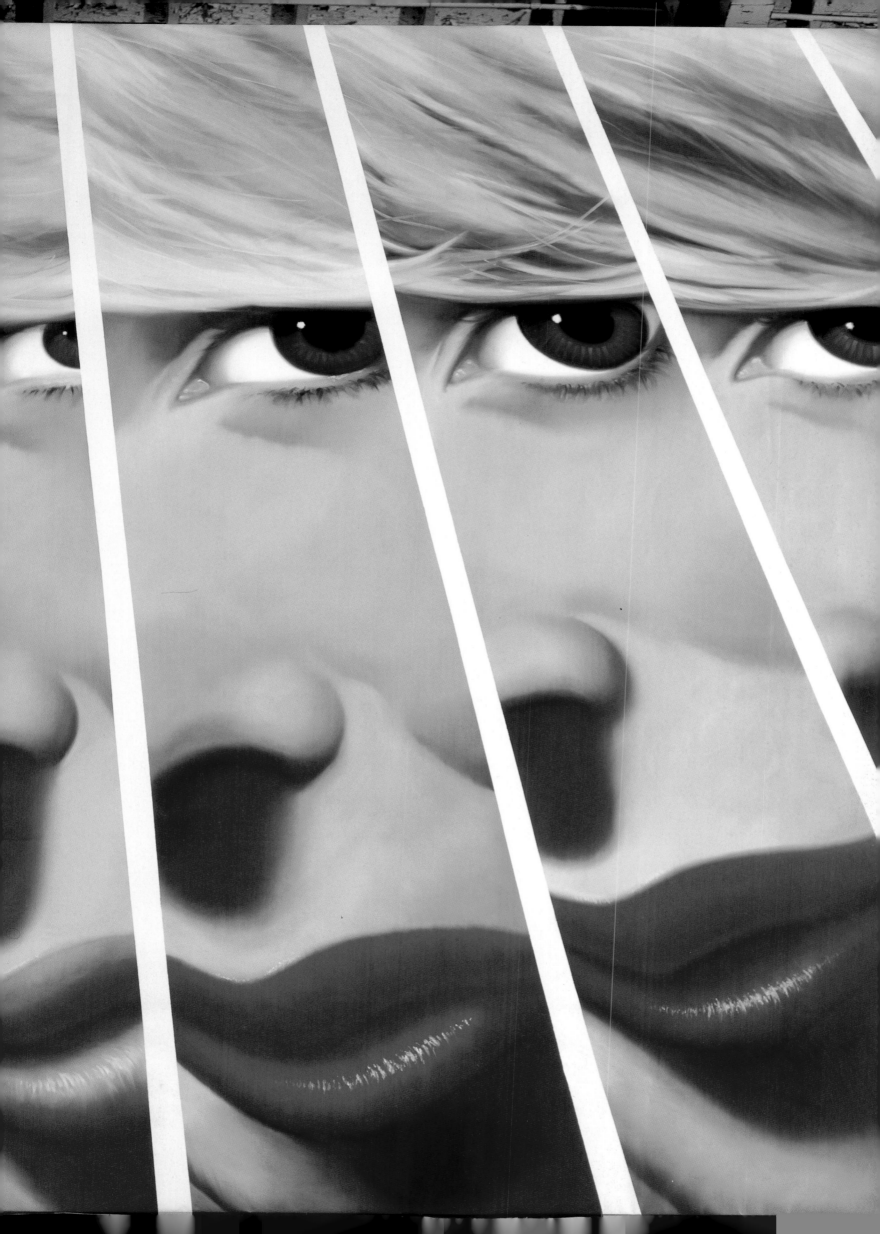

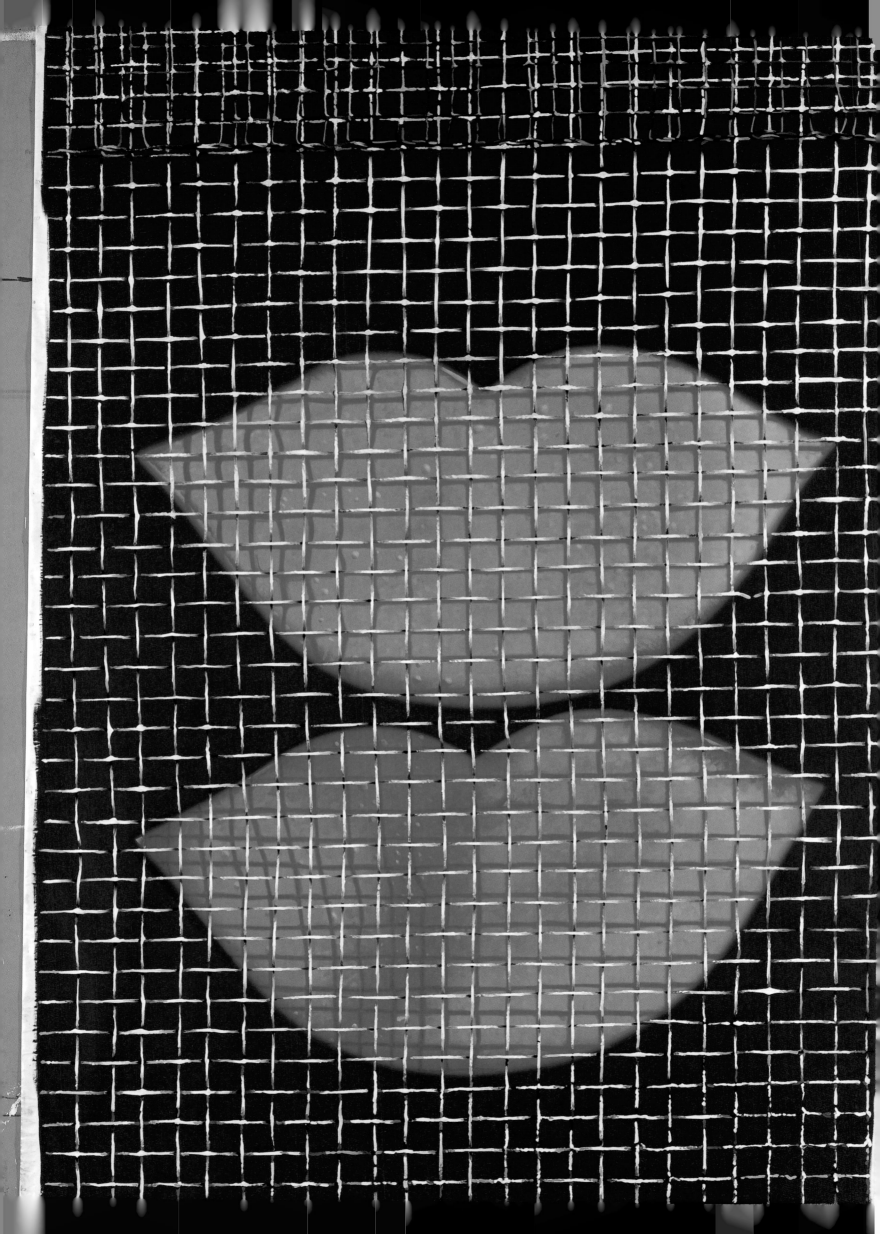

the tradition of American abstract expressionism (ill. p. 17). Abstract expressionism did have a natural appeal for him, however, as it was anti-illusionist, painting for the sake of painting. He had seen paintings of such figures as Pollock, Diebenkorn (who, he informed me, was "the most important American painter") and De Kooning at the home of collector Vincent Price during the early 1950s. At that time, Hopper must have been about fifteen or sixteen years old. Unfortunately, other works from that period remain unknown to us. A huge fire at his house in Bel Air destroyed all of the roughly three hundred paintings in 1961.

After 1958 he was able to act only on rare occasions due to an earlier confrontation with director Henry Hathaway, which had made him 'off limits' in Hollywood. At some point during that time, he also ended up in the relatively isolated surroundings of avant-garde artists in Los Angeles, where he became acquainted with an entirely different mentality and encountered a form of creativity that he had missed in the film world. In those surroundings he came to know poets of the Beat Generation and visual artists such as Wallace Berman, Ed Kienholz, George Herms and Bruce Connor, all of whom would have a significant influence on his work. They would meet at the Ferus Gallery, owned by Kienholz and Walter Hopps, or in the bar around the corner, The Beanery.[2] And in New York, he became friends with the new pop artists from the East Coast–Andy Warhol, Roy Lichtenstein, Claes Oldenburg and Allan Kaprow–and the poets Allen Ginsberg and Charles Bukowski. He sees art change from introspective abstract expressionism into the more outwardly directed art of the assemblage, pop art and the happening. The Californian assemblage art of Berman, Kienholz and Connor is different from the pop art of the East Coast. Southern California itself is pop art; the artists there have either a more critical and personal view of their surroundings (Kienholz, Connor) or a more detached view (Ed Ruscha). Having a great deal of time and being a 'man of his own means' due to his acting work, Hopper takes in the new artistic atmosphere, visits museums and galleries, and begins to experiment with assemblages himself, combining found objects with blow-ups, "which were extraordinary and ahead of their time."[3]

 Their distinguishing aspect on comparison with other assemblages from that time is his investigation of the relationship between "real objects and their representation by photographic means."[4] The earliest known assemblage is *Wilhold the Mirror Up* from 1961 (ill. p. 19). "The title refers to Hamlet's speech to the troupe preparing a dumb show, which he claims 'will hold up the mirror to nature', and to the fact that Willhold Glue is part of the assemblage. The glue bottle and a phrenological head are assembled in a box mounted on a large and dominant photograph blow-up of the head, with the legend 'Outmoding older concepts' appearing in both places."[5] Just as in *Proof* and *Chiaroscuro*, Hopper lets us think about what we see, about what is real and what is illusion[6] (ills. pp. 26, 27). As an actor and a photographer, who observes in a filmic manner, he is constantly preoccupied with this. From this point of departure he seeks a way in which to make these problematics manifest in visual art. In addition to the assemblages, Hopper also produced 'Foam Rubber Objects' during that period.[7] Initially he had considered reconstructing these sculptures–"including fences, walls, boulders and cactus with lawn"–for this exhibition, since these too, unfortunately, had been lost.

 Nonetheless, among a broad audience, Dennis Hopper has had a significantly greater reputation as a photographer and art collector, to the extent that it is sometimes stated that he has only been photographing since the disastrous fire in 1961. Actually his ultimate goal, then, was to direct a film according to his own judgment. It has, in my opinion, been aptly remarked that his photographs were always taken with an eye for film, as was already evident, in fact, from his principle of not cropping and shooting only in black-and-white. Hopper was seen with a camera so often that he earned the nickname 'The Tourist'. He photographed both the California and the New York pop-art scene from the inside out and produced beautiful portraits of not only American artists such as Kienholz, Connor, Warhol, Jasper Johns and Lichtenstein, but also their European contemporaries, including Peter Blake, David Hockney, Jean Tinguely and Martial Raysse. Moreover, works by all of these artists were purchased for his collection. Hopper followed Allan Kaprow throughout his Ice Palace project in California and recorded this on film as well. But he also made portraits of Hollywood stars and the new pop-music idols and portrayed the hippie scene of those years in unforgettable images. Hopper has a very fine eye for detail and for the right moment at which to capture the essence of his subject: "My lens is fast and my eye is keen." In 1963 he took part in the Civil Rights March with Martin Luther King. Here, with his hippie look, he met with the aggressive behavior of southern rednecks. "I realized I didn't have to be black to be hated." This acquaintance with the harsh elements at the lower end of society made a deep impression on Hopper and sharpened his political awareness. But the anger of his generation, which rebelled against the hypocrisy of the 'Affluent Society' also had a highly nihilistic and iconoclastic element. In 1967 he built the *Bomb Drop*, a replica of a device from World War II, an absurdist macho machine. These tendencies are also quite visible in *Easy Rider* and his experimental film *The Last Movie* (1971).

< **Lips,** 2000
oil paint on vinyl
19,5 x 14 feet

In 1969 Dennis Hopper finally had the chance to make a film as he saw it: *Easy Rider*. He wrote the scenario together with Terry Southern and Peter Fonda and, for an entire year, carefully sought the right locations. With *Easy Rider* he created a modern western, the road movie, using new inventions such as the flash-forward and fast cuts. With respect to this, he himself says that the experimental films of Bruce Connor had a certain influence. Furthermore, there is the revolutionary aspect of drugs being used openly and the visual interpretation of the effect that they have on one's perception. As well as the use of what we, in those days, referred to as 'real music', that is to say music not specially made for the film but existing music by famous pop groups. The two peace-loving hippies Captain America (Peter Fonda) and Billy (Dennis Hopper) are, in fact, two small-time dope dealers. The film ends with them being shot off their motorcycles by two rednecks–the young lawyer, played by Jack Nicholson, whom they encounter along the way, has already been beaten to death by then. Looming forth from beneath the portrayal of freedom is a darker, more destructive and nihilistic image of the America of that day.

Aside from the fact that Easy Rider brings success, fame and money, it also gives him the freedom to realize his dream of making a film in which he put all of his creative ideas of that time into effect: *The Last Movie*. Unlike *Easy Rider*, this film is produced with Hollywood backing. Despite a prize in Venice and a reasonably good reception in Europe, the film is shelved after two weeks in the United States. After almost two years of editing in Taos, New Mexico, Hopper had become entangled in his own destructiveness. The final product is regarded as a total flop. And yet: "His framing and sense of visual detail are evident. He likens his reflexive technique to the Abstract-Expressionist telescoping of materials: 'This is paint I'm using. See? And this is canvas. I'm showing you canvas. Now you're going to turn it upside down...This movie shows you the structure.'"[8]

After this catastrophe, the relationship between Hopper and Hollywood is in ruins. Now spending most of his time in Taos, having given up painting and photography, he leads the ultimate 'sex, drugs & rock 'n' roll' hippie life of the 1970s. Hopper had been experimenting with drugs since the fifties, as did many artists and actors from that time (and before). Now, however, drugs and alcohol slowly begin to assume control of his life. Occasionally he still does acting, as in the Wim Wenders film *Der amerikanische Freund* (1977) and as the legendary crazed photographer in Francis Ford Coppola's *Apocalypse Now*. In 1980 he is able, by chance, to direct a film in Canada, the scenario and the title conforming to his view: *Out of the Blue*. In this film about a punk teenage girl with an incestuous, alcoholic and ex-con father (Dennis Hopper), the dark side of life is shown again. This is a fascinating work with the characteristic marks of Hopper's direction: a keen eye for detail, quick cuts, but interrupted now and then by a beautiful, long Antonioni-like shot. The film ends with the girl's explosive murder of her father. Soon afterwards in an art show at a stadium in Houston, Hopper blows himself up in a dangerous stunt (*The Blow Up*, recorded on video). This happening brings a particular period to an end and is meant to be symbolic of his "rebirth into the art world". Having kicked the habit of drugs and alcohol by 1984, he makes a comeback, not only as an actor but as a visual artist.

The first paintings produced by him then, still from 1982, are peculiarly abstract expressionist and collage-like, as though he needs to start from the very beginning (ills. pp. 37-45). He devotes himself, however, primarily to his comeback in the film world. After big successes as an actor in *Blue Velvet* and *Hoosiers* (both 1986), he directs *Colors* in 1988. Around 1990 he begins to take his painting and photography seriously again. The previously mentioned graffiti paintings, inspired by *Colors*, were made by him in Taos, where he was using an old movie theater as a studio. At this point, visual art is still not something Hopper does in Los Angeles. He takes photographs in Europe, Morocco and Japan, and like his earliest ones, these are abstract studies of weathered walls with or without graffiti, weathered posters or other marks left behind by people. But now the photographs are in color, or polaroid (ills. pp. 46, 47), are more aesthetic, less harsh, show a detail more frequently. With *Framed Colors* these are blown up to large proportions and made part of a monumental series of color studies: photography is now being used purely as a painterly means–an old Hopper technique, but without the Duchamp-like irony that was employed by him in the past.

The Moroccan photographs inspire him to produce a series of paintings such as *Untitled (Morocco blue)*, 1994, a small blue monochrome divided by broad white bands of paint (ill. p. 68). Others, such as *Morocco (diptych)*, 1994, have an earthy brown undertone upon which a loose pattern of forms is painted in different colors. These, in my view, owe a debt to Richard Diebenkorn. The *Morocco* paintings are painterly in a much more traditional sense than the aforementioned graffiti paintings from 1991 and 1992 which he produced after the film *Colors*. The latter are moreover combined with blurred stills that are digital video print outs from the movie camera that have been printed onto canvas. With respect to this combination, he says the following: "It's a juxtaposition thing; it's what makes California a very pretty but violent place."[9] And on the use of the graffiti walls: "I'm playing with it, sort of making fun of it and, at the same time, I'm reminding people that it's not really a game." The critic Peter Clothier believes that the effect of Hopper's painterly approach "is of a

powerful simplicity, a rejection of the surface appeal of attractive composition and color in favor of a naive, even rough-hewn approach that seems refreshingly unsophisticated and direct," but in his final assessment he is more cautious: "We are left with some handsome and accomplished paintings–but works which tease us with a referential bark that has somewhat lost its bite."[10]

Perhaps, over the years, Dennis Hopper has acquired a different outlook on his art and life. He has started to collect art once again, including work by Jean-Michel Basquiat, Keith Haring, Kenny Sharff, David Salle and Julian Schnabel. In 1996 he played in this last artist's film on the life of Basquiat. In Hopper's own film *Backtrack* the role of leading actress Jody Foster was modelled after the visual artist Jenny Holzer. This film no longer has the destructive undertone of his earlier films but is still distinctly Dennis Hopper.

His art continues to deal with the problematics of reality versus illusion, photography versus painting. The fundamental change, for him, lies with an acceptance of Los Angeles. The city with which he has always had a love-hate relationship, in which he basically had to live because of the film industry being there, has now become his home. In Hollywood, Hopper now enjoys the status of a Grand Old Star. In the most recent works, one finds a mixture of the magnification and revival of his past as a filmmaker and visual artist, on the one hand, and the creation of a present-day Southern California Urban Landscape one the other– a tribute to Los Angeles. His latest projects include a number of *Wall Assemblages* and two six-meter-tall advertisement 'men'. The *Wall Assemblages* are, in fact, parts of sets, segments of wall standing free in space–details from the city, selected by Hopper and reproduced for their inadvertent beauty. The reality of the city is now directly linked with the illusion of a filmset.

Even now, driving through the endless city with Dennis Hopper means learning to look at details, peculiarities, at the beauty of walls with or without graffiti, at the gigantic billboards, weathered or new.

Six months ago he pointed out a 'Mexican man', more than six meters tall, in front of a restaurant. I'm having that one reproduced, he told us. And now we are on our way to the workshop where the copy of the 'Mexican man' is being made. Astounding: not only *La Salsa Man* but also the original *Mobil Man* is standing there–big as life, American through and through. Found objects made anew: the ultimate Californian pop culture and Hollywood illusion, all in rolled into one.

Stepping back in time once more: in 1963 Dennis Hopper met Marcel Duchamp at the opening of his retrospective in the Pasadena Art Museum, organized by Walter Hopps. The exhibition made a vivid impression, or as Ed Ruscha put it, "If he hadn't come along, we would have needed to invent him." Duchamp remains Hopper's great inspiration to this day. Just as with the images that he now 'borrows' from his earlier work, the set-like *Wall Assemblages* and two giants should be regarded as "...going on Duchamp's theory that the artist of the future will point his finger and say: 'That's art.'"[11]

1 Dennis Hopper, Michael McLure and Walter Hopps, *Dennis Hopper: Out of the Sixties*, Pasadena, 1986.

2 Kienholz's *Beanery* (1965) in the collection of the Stedelijk Museum Amsterdam is an exact replica of the original, two-thirds of the actual size. With the exception of one, all of those sitting at the bar have a clock instead of a face. Hopper has told me that he is the one without the 'clockface'.

3 Dennis Hopper, Michael McLure and Walter Hopps, *Dennis Hopper: Out of the Sixties*, Pasadena, 1986.

4 Robert Dean, "Dennis Hopper," in: Anne Ayres, *Forty Years of California Assemblages*, Wight Art Gallery, University of California at Los Angeles, 1989.

5 Dean, 1989.

6 There is uncertainty with respect to the dating of *Proof*. Dean indicates 1960, and Hopper himself situates the work in 1963, as he does *Chiaroscuro*, whereas it has just as much in common with *Wilhold the Mirror Up*.

7 These foam-rubber sculptures were exhibited in London (Robert Fraser Gallery) and at the Pasadena Art Museum in 1966.

8 William Charles Siska, *Modernism in the Narrative Cinema: The Art Film as a Genre* (New York, 1980), p. 85.

9 Gussie Fauntleroy, June 1992.

10 Peter Clothier, "Dennis Hopper at James Corcoran," in: *Art in America*, June 1992.

11 Statement by Dennis Hopper quoted from: Peter Clothier, "Hip Hopper," *Art News*, September 1997.

Installation view, 1967
Kennedy Suite
Fred Hoffman Fine Art

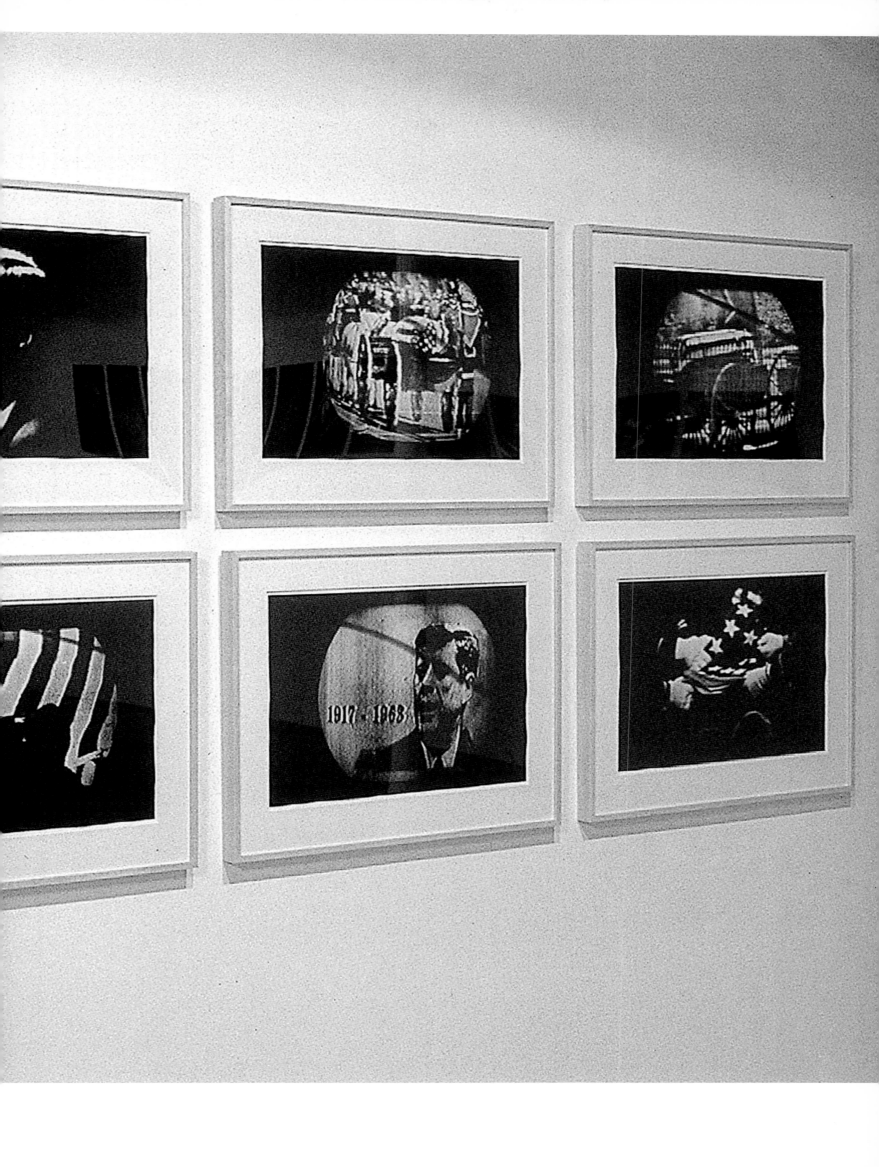

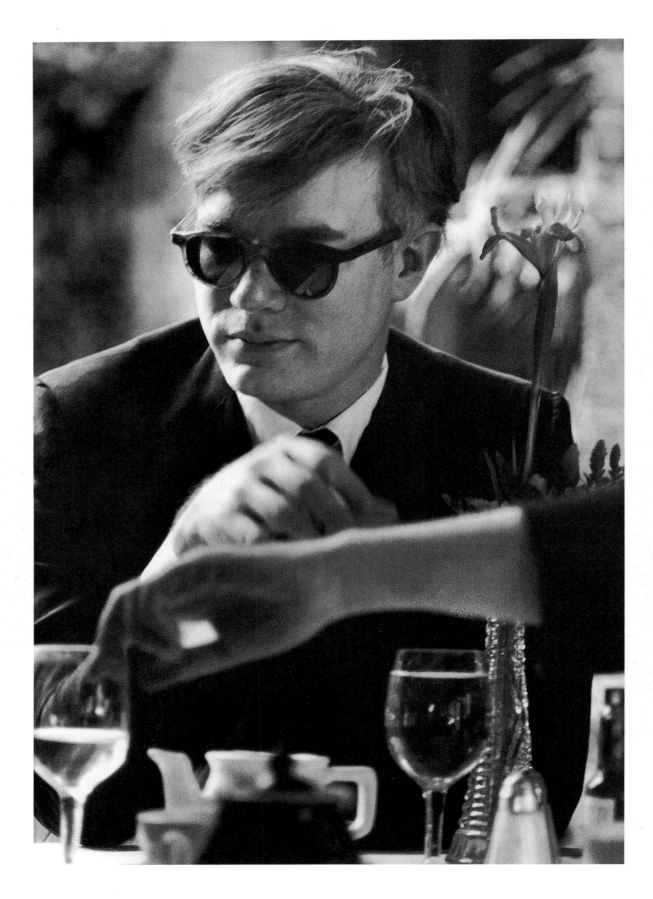

Andy Warhol (at table), 1963
gelatin silver print
20 x 16 inches

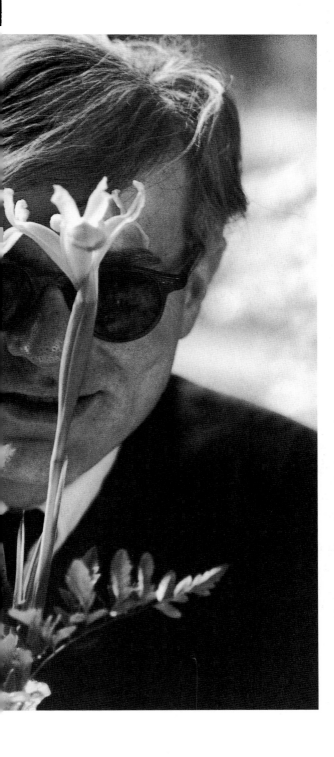

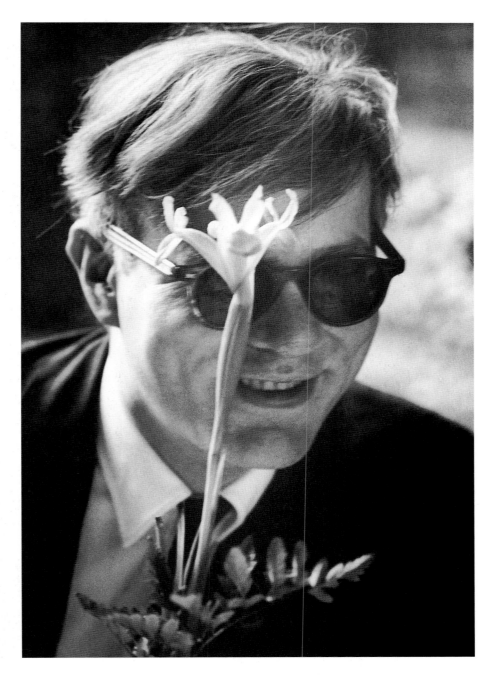

Andy Warhol (with flower, smiling), 1963
gelatin silver print
20 x 16 inches

Andy Warhol (with flower, light smile), 1963
gelatin silver print
20 x 16 inches

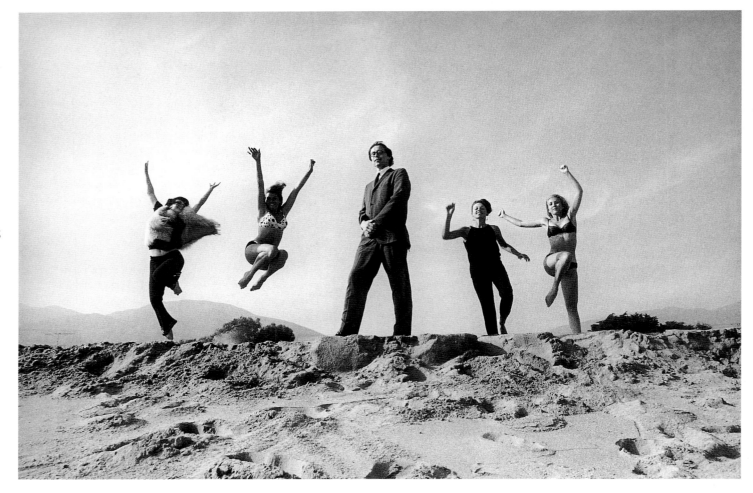

Bruce Conner at the Beach, 1964
gelatin silver print
16 x 20 inches

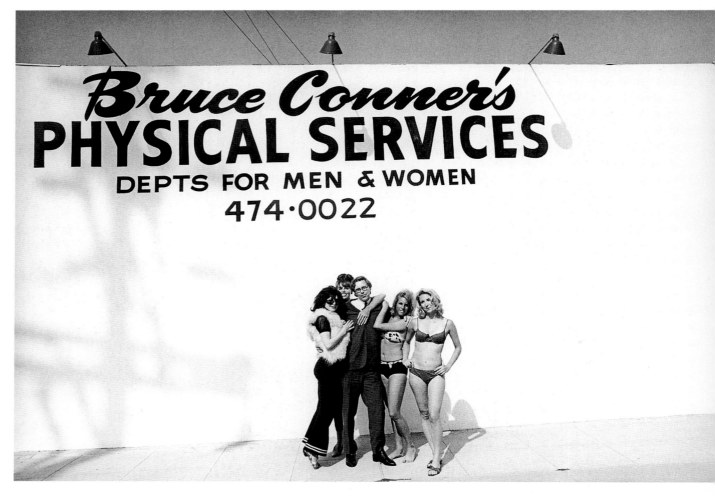

Bruce Conner's Physical Services #2, 1964
gelatin silver print
16 x 20 inches

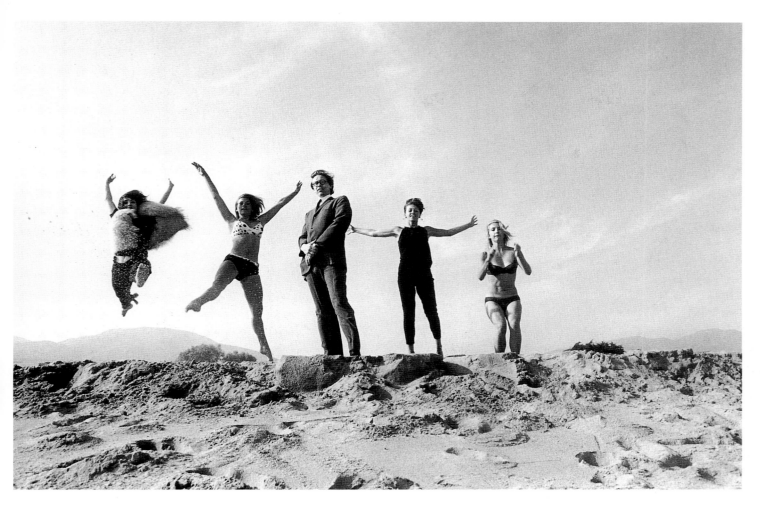

Bruce Conner with Four Women, 1964
gelatin silver print
16 x 20 inches

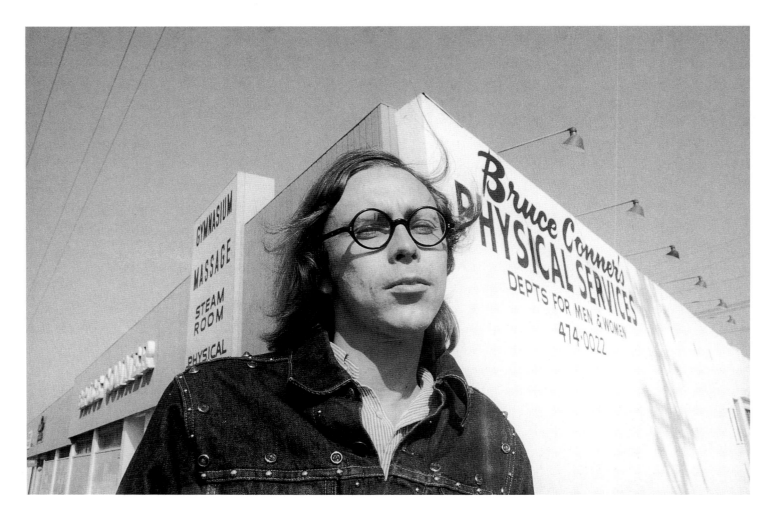

Bruce Conner (at corner of building), 1964
gelatin silver print
16 x 20 inches

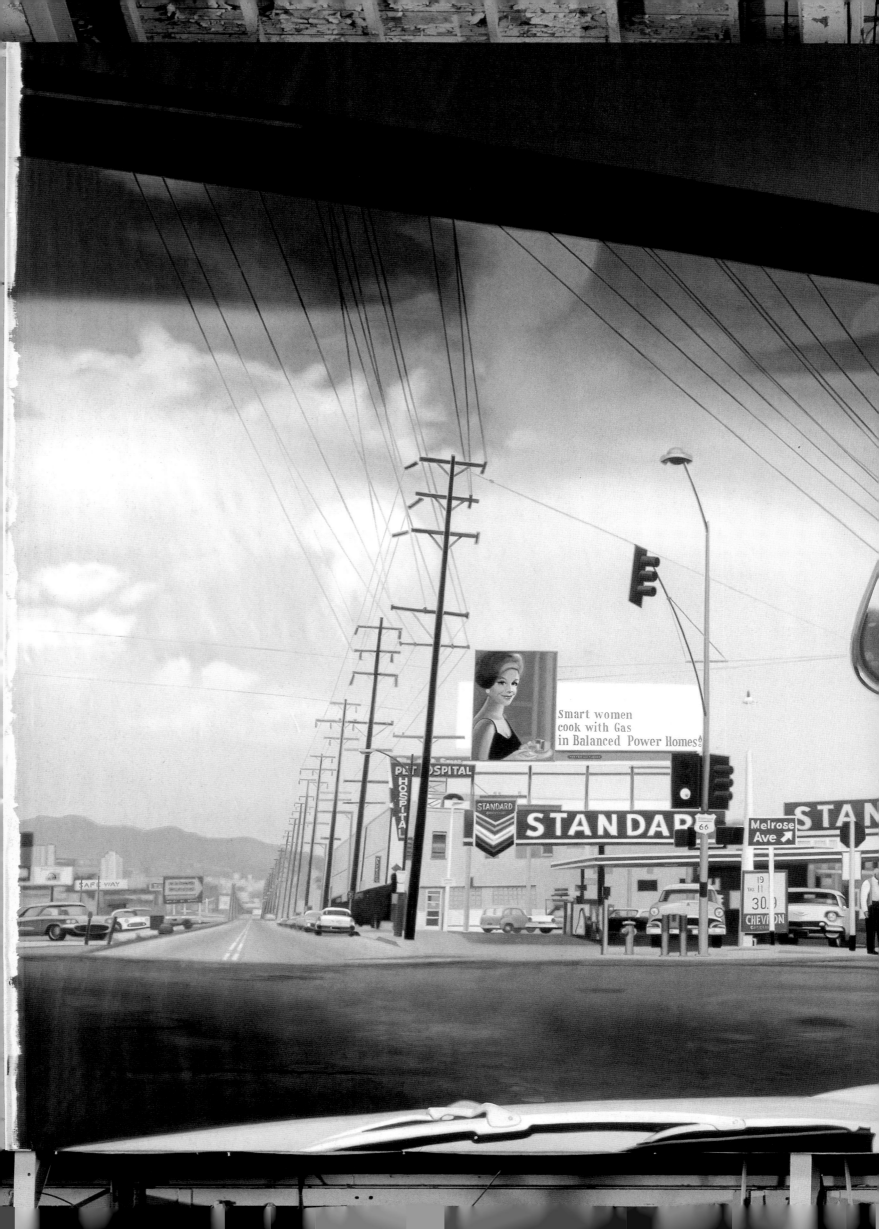

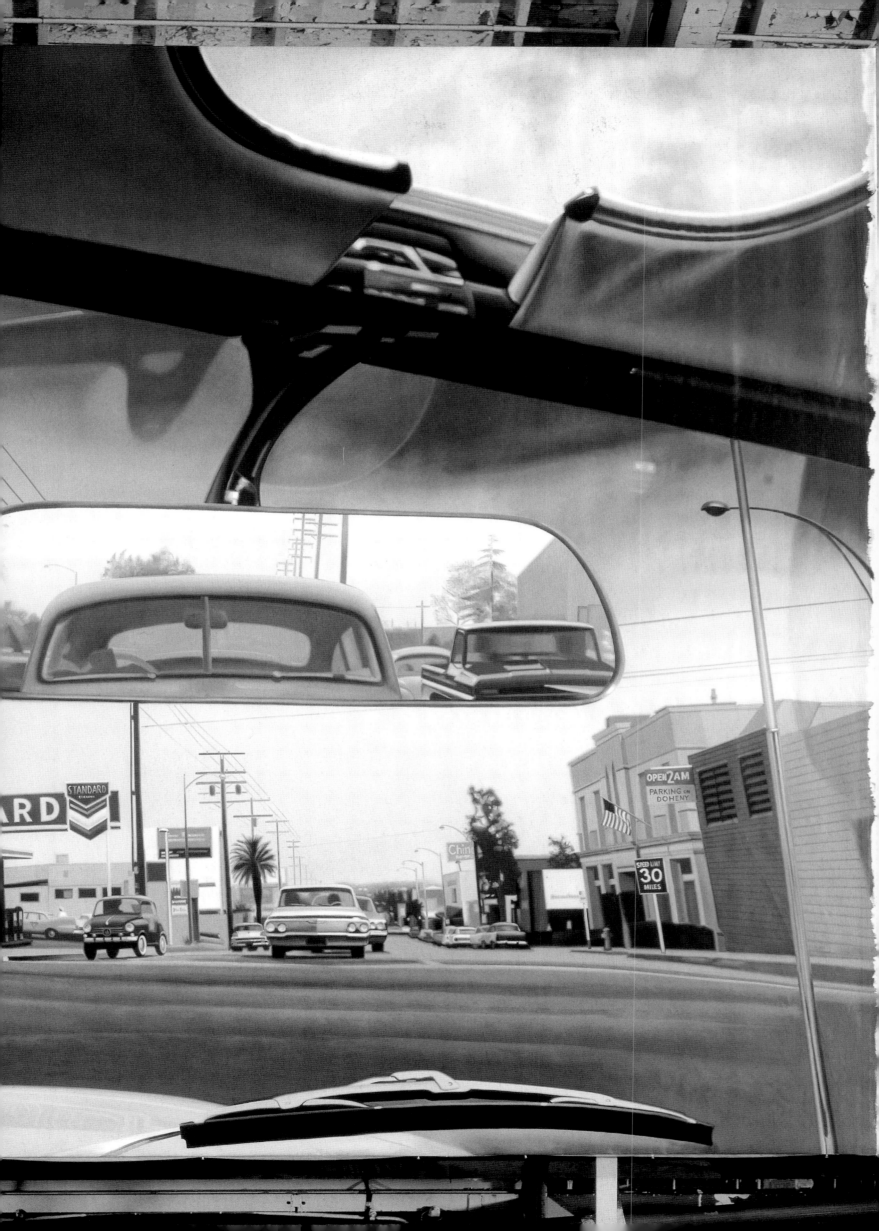

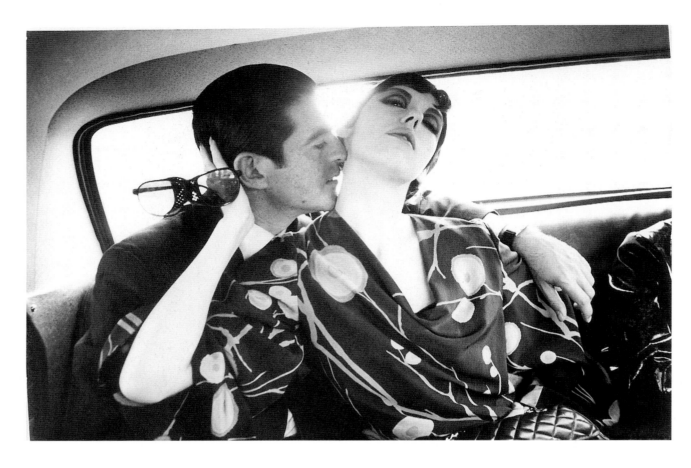

Irving Blum and Peggy Moffat, 1961
gelatin silver print
16 x 24 inches

Dean Stockwell, 1964
gelatin silver print
16 x 24 inches

< **Double Standard,** 2000
oil paint on vinyl
14 x 21.5 feet

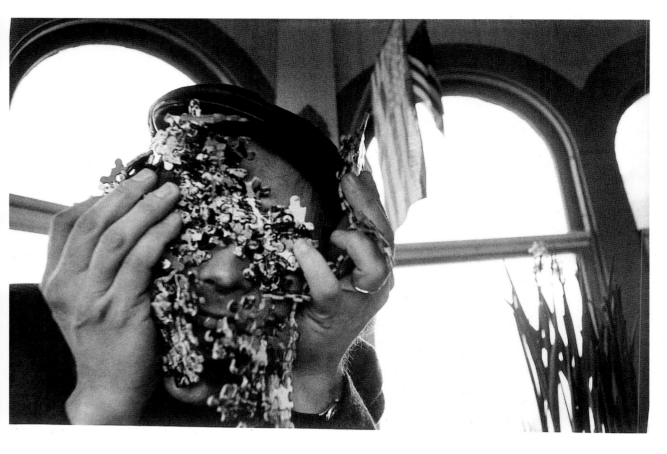

Bruce Conner with puzzle, 1964
gelatin silver print
16 x 24 inches

Robert Rauschenberg, 1966
gelatin silver print
16 x 24 inches

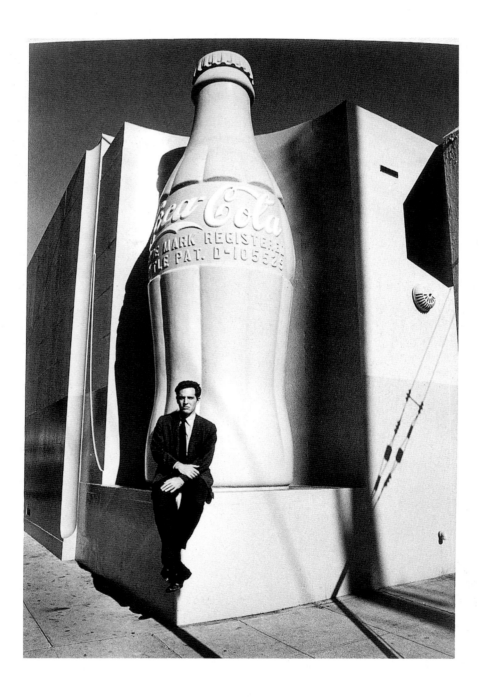

Donald Factor at Coca-Cola, 1964
gelatin silver print
24 x 16 inches

Claes Oldenburg (portrait), 1966
gelatin silver print
24 x 16 inches

John Altoon, 1964
gelatin silver print
24 x 16 inches

Bill Cosby (portrait), 1962
gelatin silver print
24 x 16 inches

Edward Ruscha, 1964
gelatin silver print
16 x 24 inches

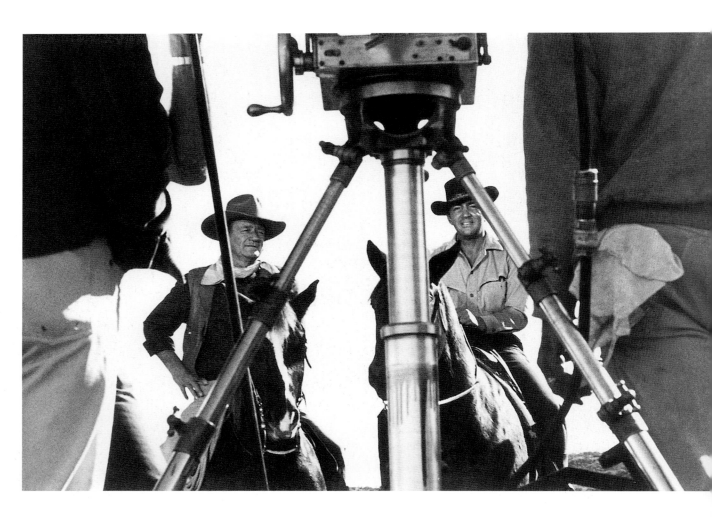

John Wayne and Dean Martin, 1962
gelatin silver print
16 x 24 inches

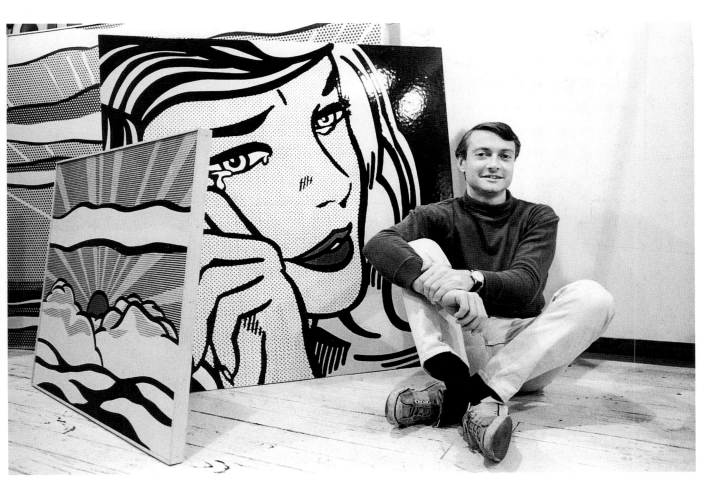

Roy Lichtenstein, 1964
gelatin silver print
16 x 20 inches

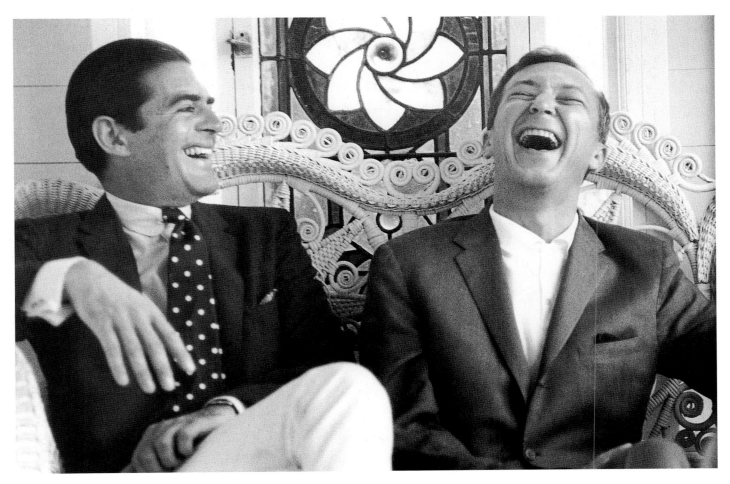

Irving Blum & Jasper Johns (seated), 1964
gelatin silver print
16 x 20 inches

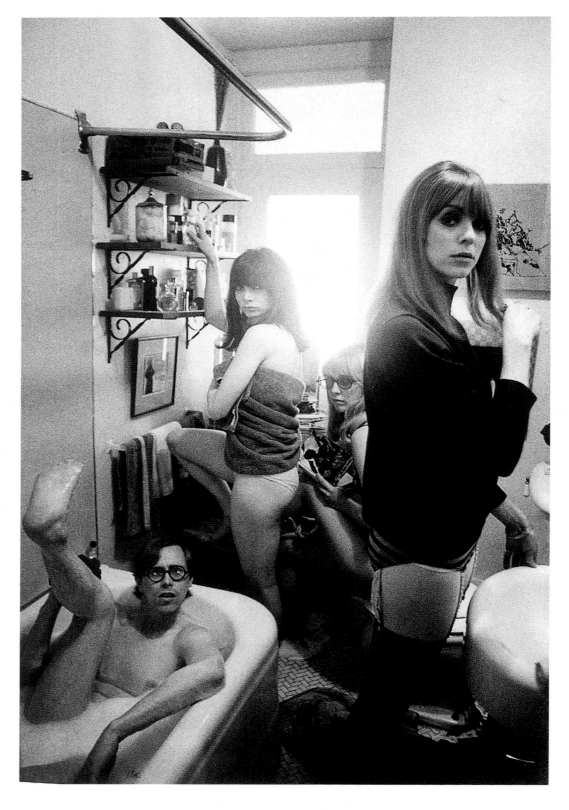

Bruce Conner, Toni Basil, 1965
gelatin silver print
24 x 16 inches

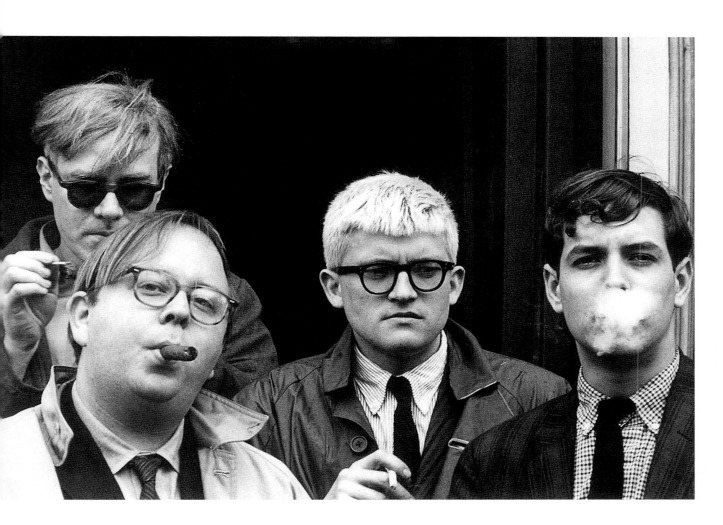

Andy Warhol, Henry Geldzahler, David Hockney, Jeff Goodman, 1963
gelatin silver print
16 x 24 inches

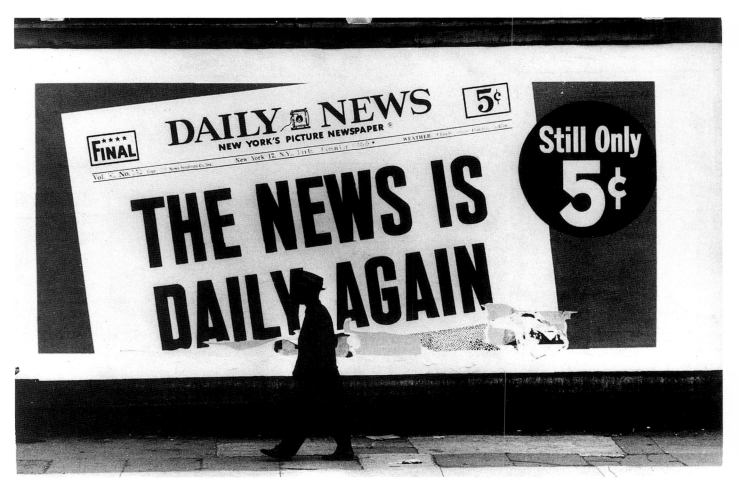

Daily News (Harlem, New York), 1962
gelatin silver print
16 x 24 inches

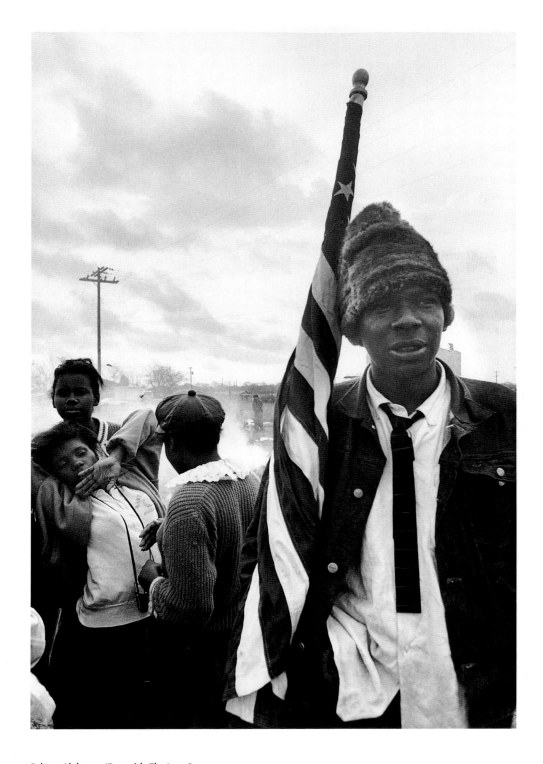

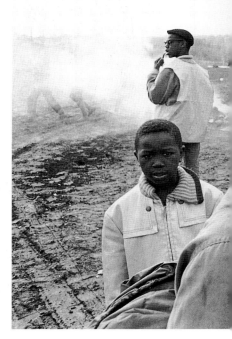

Selma, Alabama (Full Employment), 1965
gelatin silver print
20 x 24 inches

Selma, Alabama (Boy with Flag), 1965
gelatin silver print
24 x 16 inches

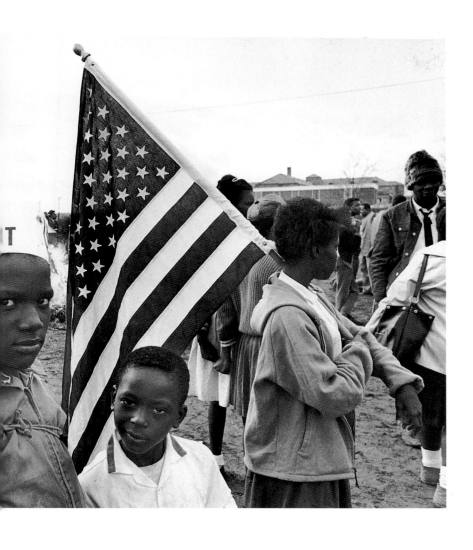

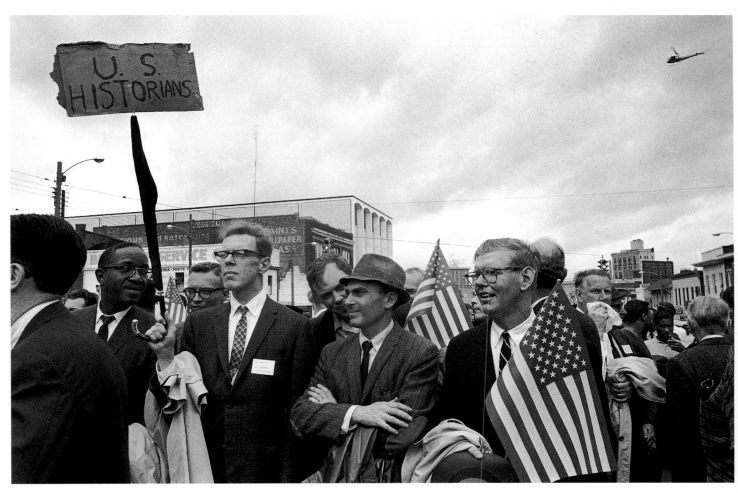

Selma, Alabama (U.S. historians), 1965
gelatin silver print
16 x 24 inches

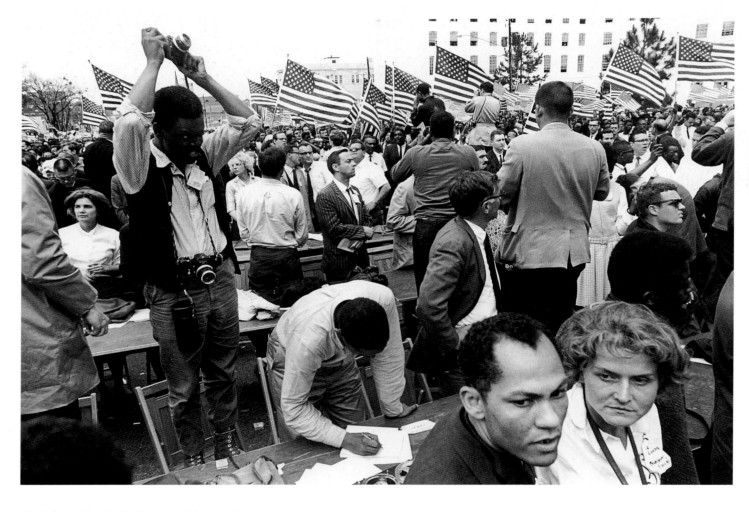

March from Selma to Montgomery, Alabama, 1965
gelatin silver print
20 x 24 inches

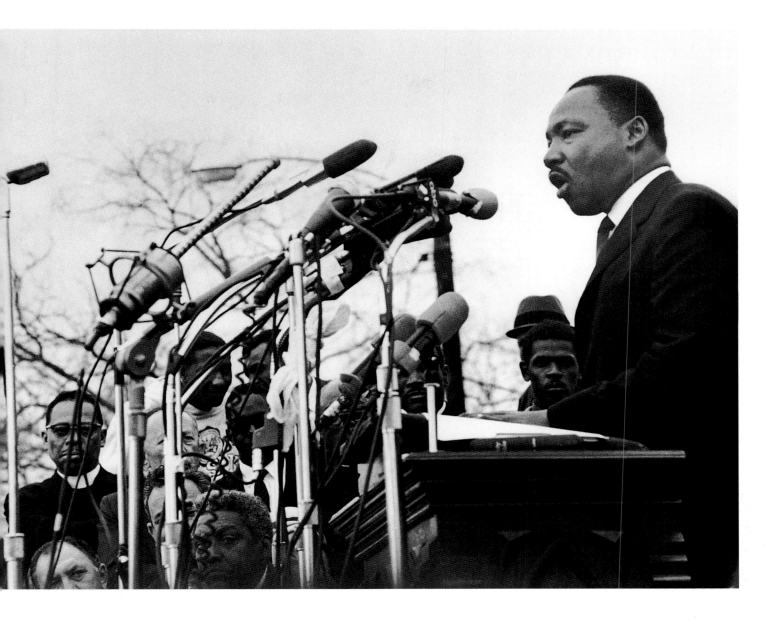

Martin Luther King Jr., 1965
gelatin silver print
16 x 24 inches

LA Times Final, 2000 >
oil paint on vinyl
14 x 21.5 feet

Sign of LAT

LOS ANGELES
Times

30, 1963

E NEWS

FINAL

DAILY 10¢

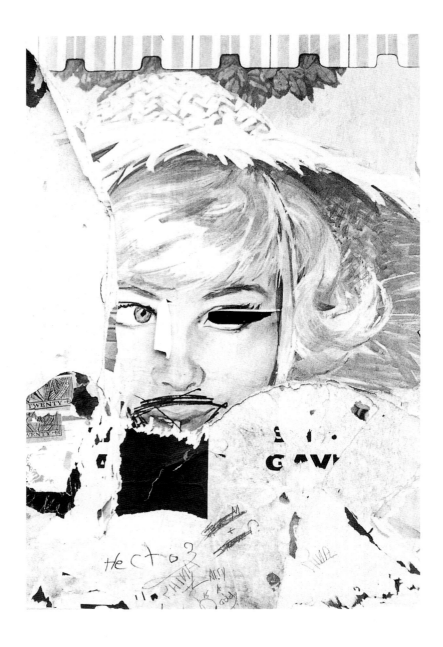

Torn Poster (Girl), 1964
gelatin silver print
24 x 16 inches

Torn Poster (Girl), 2000 >
water based primer, oil paint on vinyl
14 x 9.5 feet

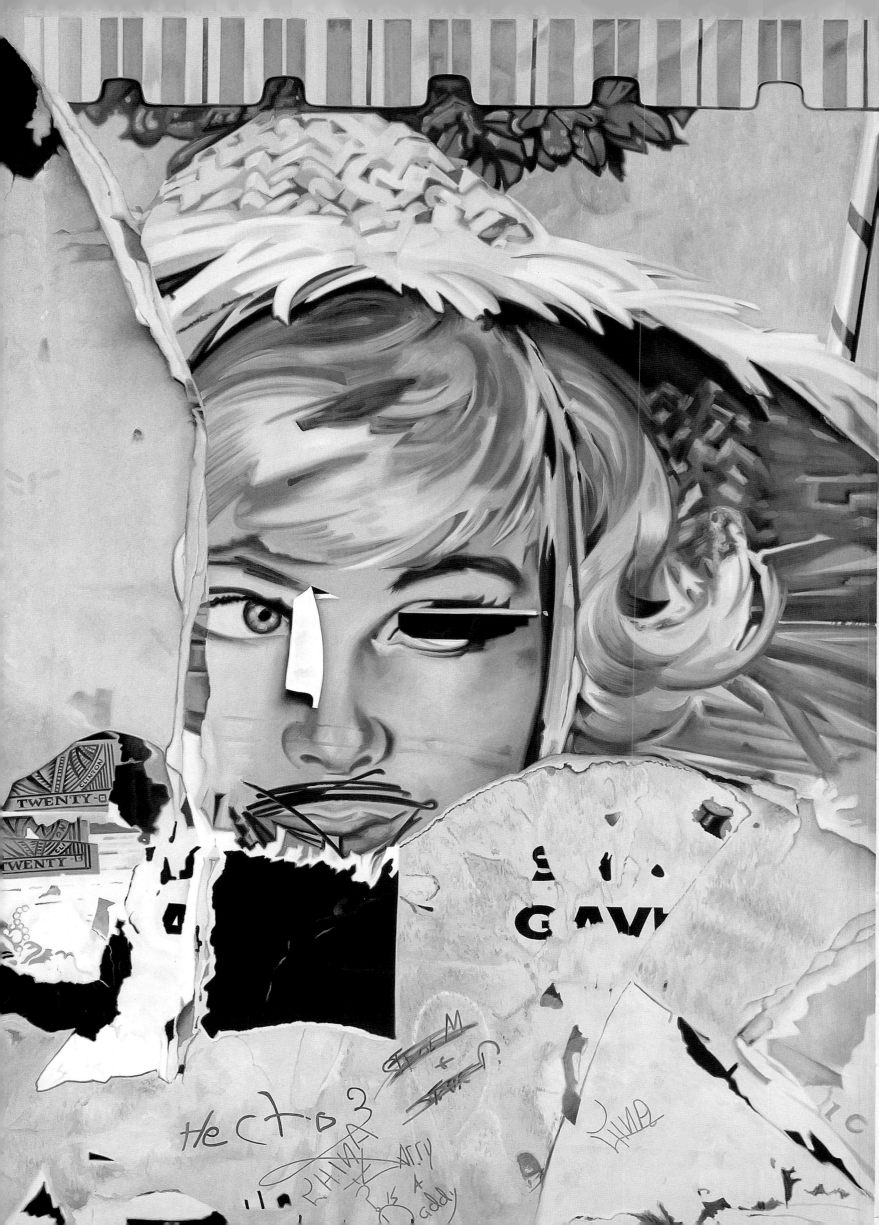

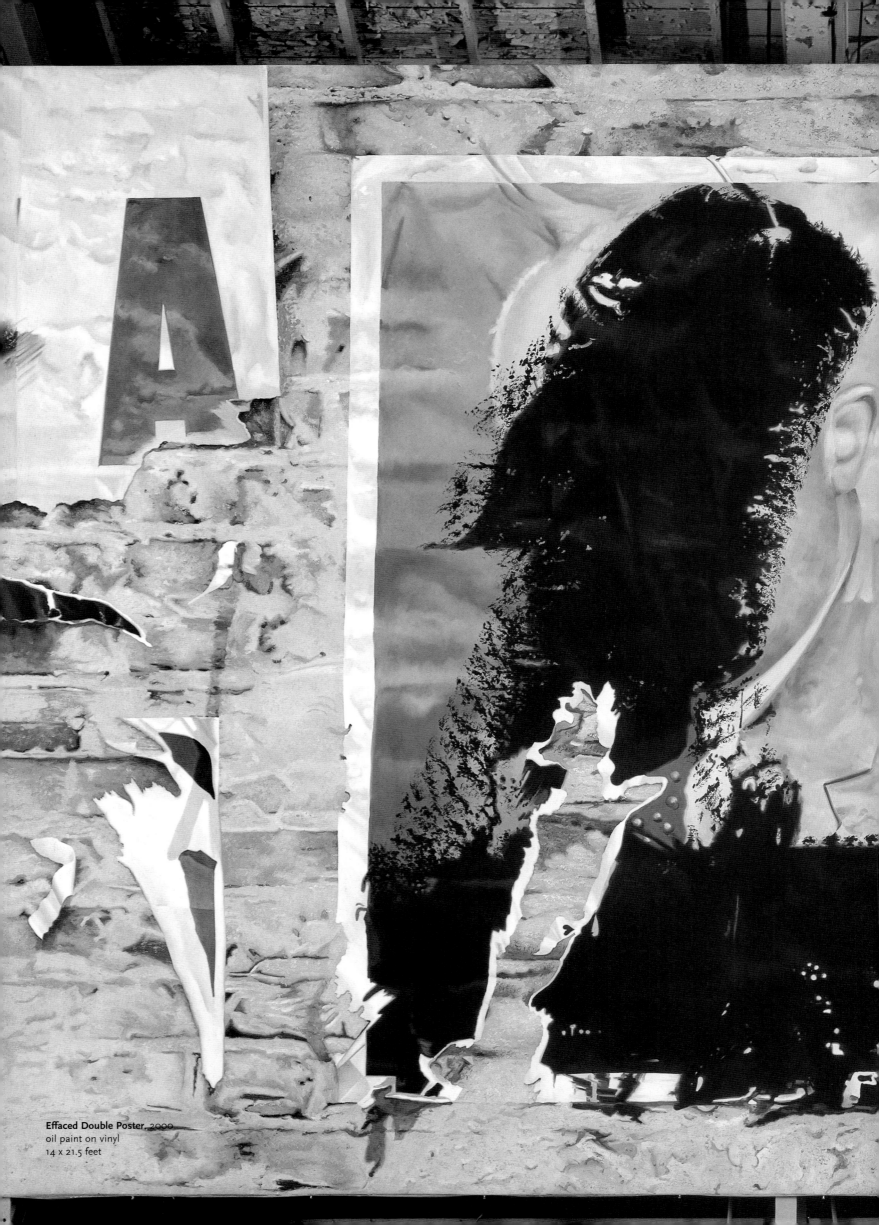

Effaced Double Poster, 2000
oil paint on vinyl
14 x 21.5 feet

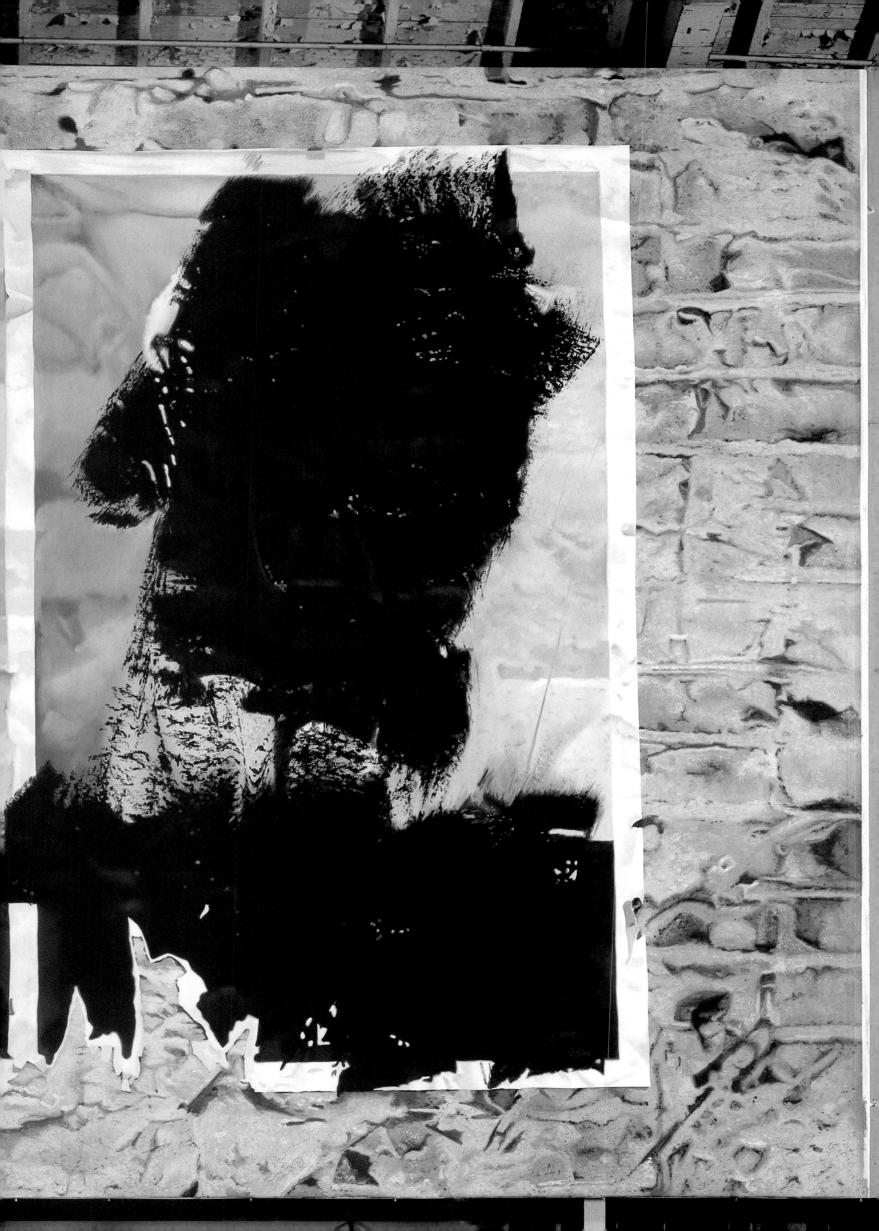

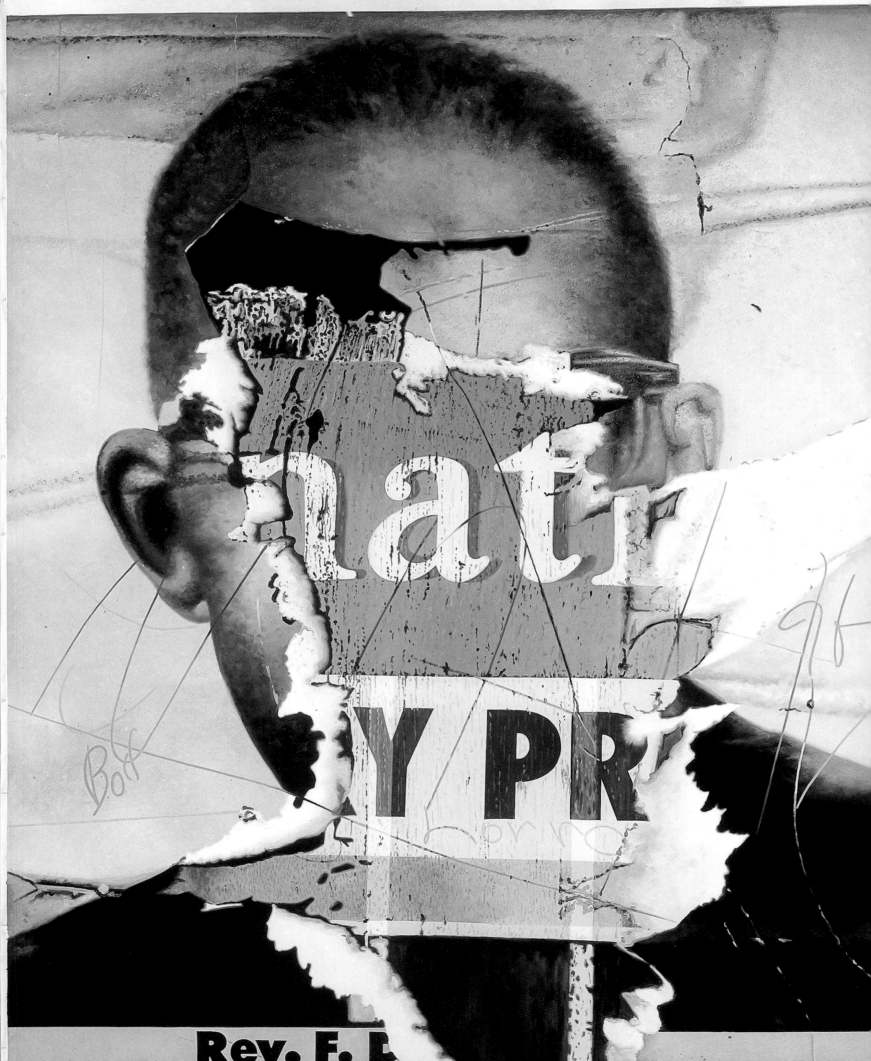

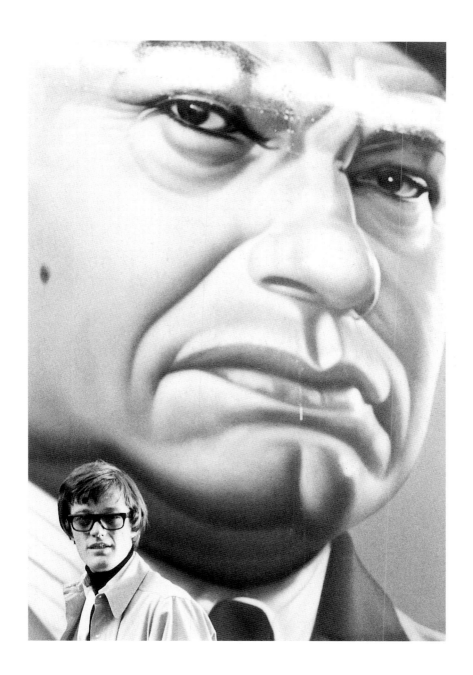

< **Torn Poster (Elect)**, 2000 **Peter Fonda (with Edward G.)**, 1964
water based primer, oil paint on vinyl gelatin silver print
14 x 9.5 feet 24 x 16 inches

Jane Fonda, 1964
gelatin silver print
24 x 16 inches

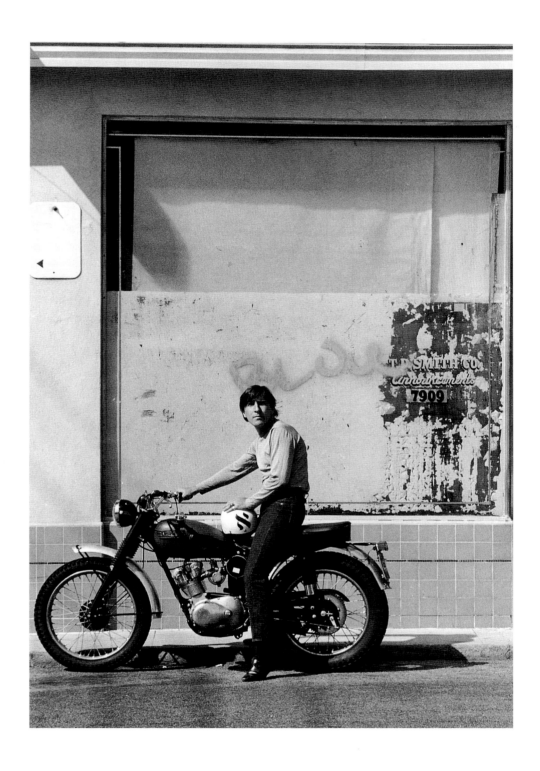

Wallace Berman, 1964
gelatin silver print
20 x 16 inches

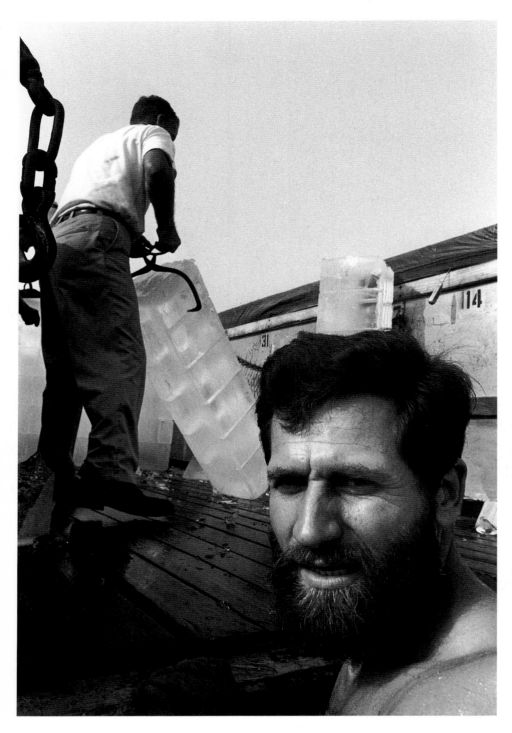

Allan Kaprow (ice palace happening, looking outward), 1964
gelatin silver print
24 x 16 inches

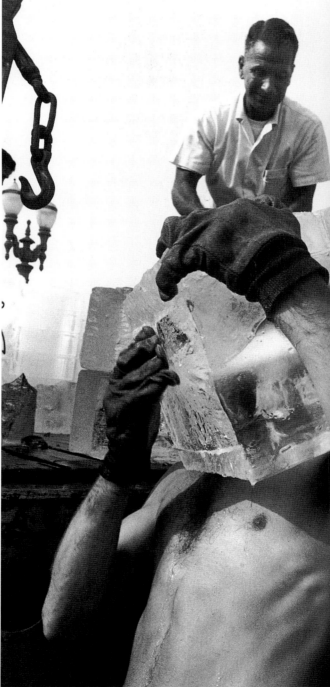

Allan Kaprow (ice palace happening, face obscured), 1964
gelatin silver print
24 x 16 inches

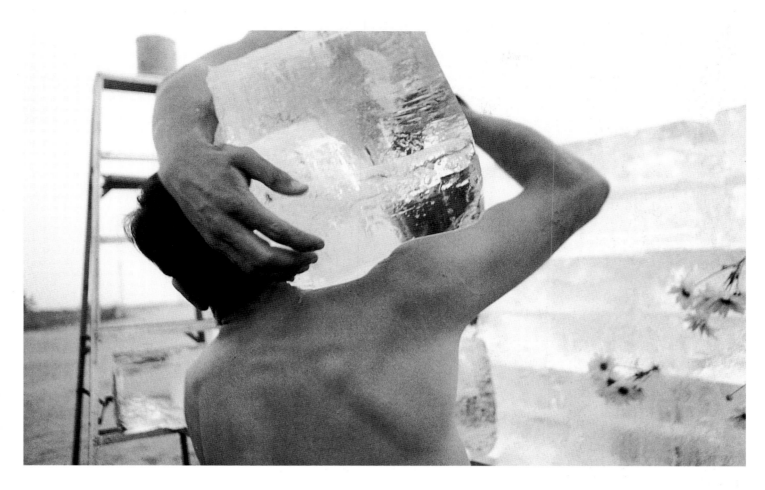

Allan Kaprow (with ice block), 1964
gelatin silver print
16 x 20 inches

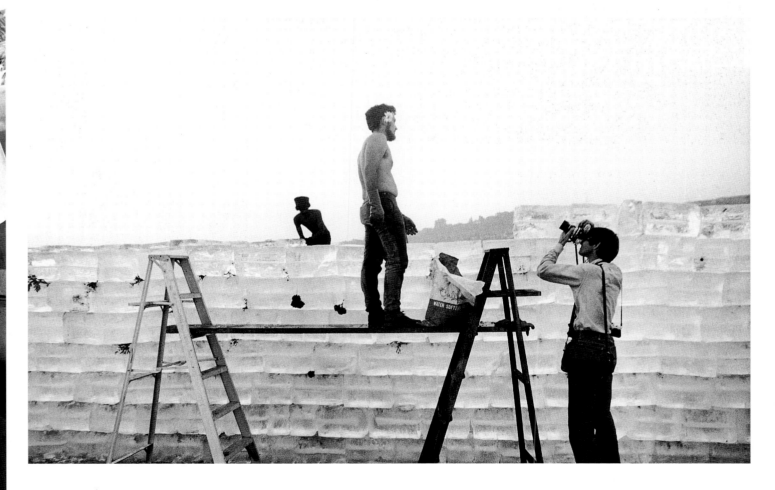

Allan Kaprow (ice palace), 1964
gelatin silver print
16 x 20 inches

Biker, 1961
gelatin silver print
24 x 16 inches

Biker couple, 1961
gelatin silver print
16 x 24 inches

Biker couple, 2000 >
oil paint on vinyl
14 x 21.5 feet

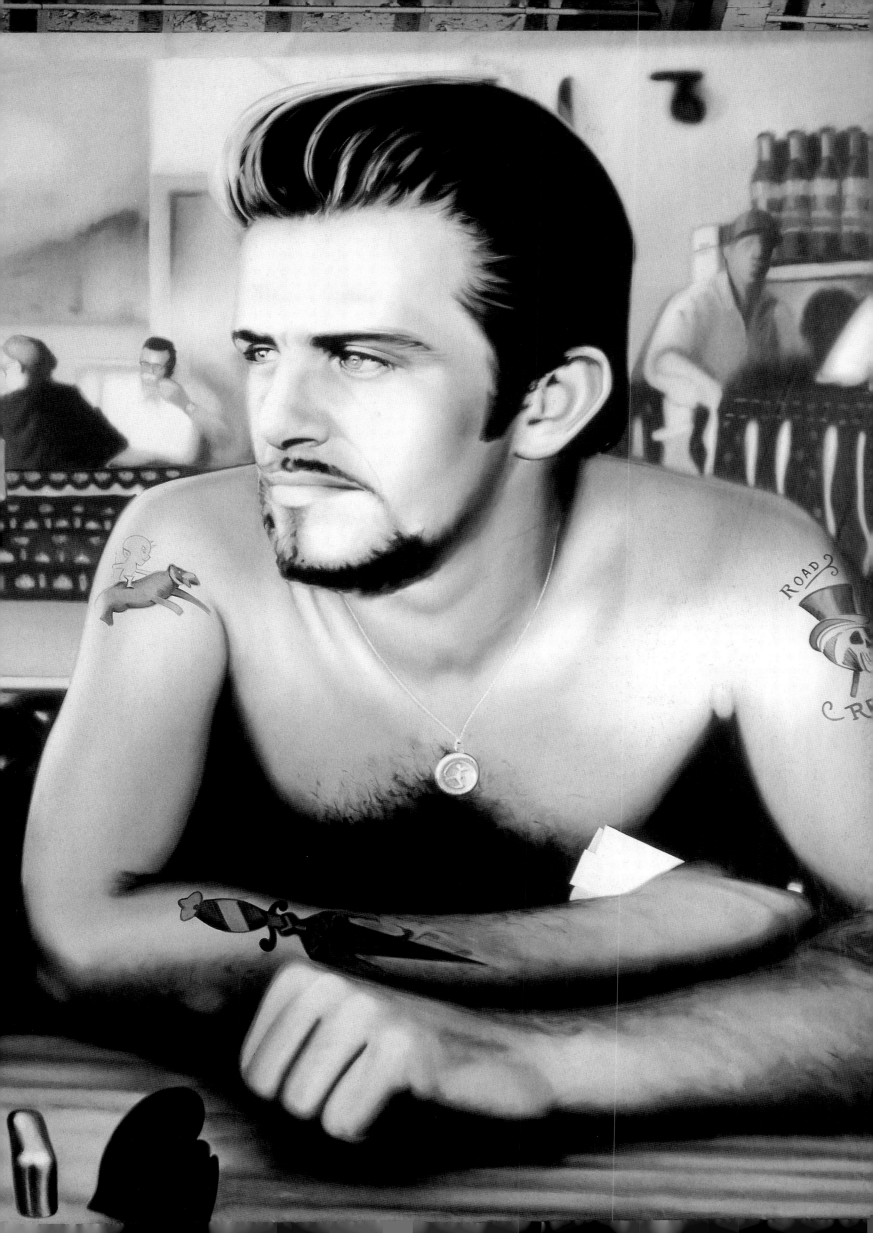

Andy Warhol
Dennis Hopper, 1971
synthetic polymer
and silkscreen on canvas
40 x 40 inches

Exhibitions

solo exhibitions

1961
"Photographs,"
photo lab/gallery of Barry Feinstein, Los Angeles
1964
"Assemblages," Primus/Stuart Gallery, Los Angeles
1968
Exhibition of the installation *Bomb Drop* at the Pasadena Art Museum,
Pasadena
1970
"Dennis Hopper: Black and White Photographs"
(organized by Henry T. Hopkins),
Fort Worth Art Center Museum, Fort Worth, Texas
Exhibition at the Denver Museum of Contemporary Art, Denver
1971
The Corcoran Gallery of Art, Washington D.C.
1982
"Photography," Paton Gallery , England
"Dennis Hopper: Art on the Edge,"
The Film Center, School of the Art Institute of Chicago, Chicago
1983
"Shot on the Run" (100 photographs and opening night
self-explosion performance),
Rice Media Center, Rice University, Houston, Texas
"Paintings and Assemblages by Dennis Hopper,"
Studio One Gallery, Houston, Texas
1984
"Dennis Hopper: New Paintings" (also included 1960s photography),
Return Gallery, Taos, New Mexico Graham Parsons Gallery, London
1986
"Dennis Hopper: Out of the Sixties," Tony Shafrazi Gallery, New York
"Dennis Hopper Photographs," Arts Lab, Birmingham
1987
Union County Gallery, Cranford, New Jersey
"Out of the Sixties: Photographs," Sena Galleries West, Santa Fe,
New Mexico
1987–1988
"Dennis Hopper: From Method to Madness," Walker Art Center,
Minneapolis, Minnesota; Film Forum, New York; Institute of
Contemporary Art, Boston; Cleveland Institute of Art, Cleveland, Ohio;
Houston Museum of Fine Arts, Houston, Texas; Pacific Film Archives,
Berkeley, California
1988
"Out of the Sixties: Fotografie di Dennis Hopper,"
Salone La Stampa, Turin
"Photographs," Kunsthalle Basel, Basel; Deutsch-Amerikanisches
Institut, Tübingen; Musée de l'Elysée, Lausanne; 20èmes Rencontres
Internationales de la Photographie, Arles; Foto 89, Amsterdam;
Filmoteca Generalitat Valenciana 46, Sala Parpalló, Valencia; Escuela de
Artes Aplicadas y Oficios Artisticos de Almeria, Almeria
Galerie Thaddaeus Ropac, Salzburg
Galerie Hans Mayer, Düsseldorf
1989
"Photographs 1961–67," Shibuya Parco Gallery, Tokyo; Sapporo Parco,
Sapporo; Kumamoto Parco, Kumamoto; Joju-in, Kiyomizu Temple,
Kyoto; Osaka Shinsaibashi Parco, Osaka
1990
Boulakia Gallery, Paris
Stockholm Film Festival, Stockholm
1991
"Silver and Gold Photographic Enamel Exhibition of Silkscreens on
Aluminium," 72 Market Street Oyster Bar & Grill, Venice, California

1992
"New Work," James Corcoran Gallery, Santa Monica, California
"Photographs and Paintings, 1961–1992," Galerie Thaddaeus Ropac,
Paris
1992–1993
"Photographs and Paintings, 1961–1993," Spielraum für Kunst, Fürth;
Württembergischer Kunstverein, Stuttgart; St. Ingbert-Saarland Museum,
Saarbrücken; Haus am Waldsee, Berlin; Lenbachhaus, München;
Kunsthalle Kiel, Kiel; Kunstsammlung Cottbus, Brandenburg;
Sächsischer Kunstverein, Dresden; Schlossmuseum Beeskow, Beeskow;
Kunstverein Göttingen, Göttingen
1993
"Bad Heart: Fotografies i Pintures 1961–1993," Frontó Colom,
Universitat Pompeu Fabra, Barcelona
1994
Exhibition in Andorra, Spain
Photographic Resource Center, Boston University, Boston
"Dennis Hopper: A Tourist," Joju-in, Kiyomizu Temple, Kyoto;
Studio 0422, Kichijoji Parco, Tokyo; Sapporo Parco, Sapporo
1995
"Dennis Hopper. Fotografie 1961–1967," Gallery Karolinum (Agentura
Carolina), Prague
1996
"Color Photography," Ochi Fine Art, Ketchum, Idaho
"New Photographs," Tony Shafrazi Gallery, New York
1996–1997
"Exhibition and Film Series," Museum of Contemporary Art, San Diego,
California
1997
"Dennis Hopper: The Sixties, The Eighties, and Now,"
Fred Hoffman Fine Art, Santa Monica, California
"Dennis Hopper: Forms of Indifference," Galerien Bittner & Dembinski,
Kassel
"Dennis Hopper," Center for Photographic Arts, Carmel, California
"Dennis Hopper: Italian Walls," Palazzo Marino alla Scala, Milan
1998
"Dennis Hopper," Sundance, Utah
"Dennis Hopper: Four Decades," Ansel Adams Center,
San Francisco, California
"Dennis Hopper: Fotografias," Metta Galeria, Madrid
"Dennis Hopper: Abstract Reality," Parco Gallery, Tokyo
"Dennis Hopper: Abstract Reality," Galerie Hans Mayer, Düsseldorf
1999
"Reflections," Galerie Hans Mayer, Berlin
2000
"Dennis Hopper: Abstract Reality," Craig Krull Gallery, Santa Monica,
California
"American Pictures 1961–1967," MAK Center, Los Angeles
2001
International traveling Retrospective Exhibition
(organized by the Stedelijk Museum, Amsterdam and the MAK Museum
für Angewandte Kunst, Vienna)

group exhibitions

1966

"Los Angeles Now: Larry Bell, Wallace Berman, Jess Collins, Bruce Conner, Llyn Foulkes, Dennis Hopper, Craig Kauffman, Ed Ruscha," Robert Fraser Gallery, London

1968

"Bomb Drop," The Pasadena Art Museum, Pasadena

1970

"Survey of the Sixties," Spoleto Festival dei Due Mondi XIII, Spoleto, Italy

1984

Stables Art Center, Taos, New Mexico

1987

"The New Who's Who," Hoffman Borman Gallery, Santa Monica, California

"The International Art Fair: Art LA 1987" (exhibited by Tony Shafrazi Gallery of New York), Los Angeles

1989

"Forty Years of California Assemblage," Wight Art Gallery, University of California, Los Angeles; San Jose, California; Fresno, California; Omaha, Nebraska

"Dennis Hopper/George Herms," L.A. Louver, Venice, California

"1964–1974," G. Ray Hawkins Gallery, Los Angeles

1992

"The International Art Fair: Art Frankfurt 1992" (exhibited by Galerie Hans Mayer of Düsseldorf), Frankfurt

"Dennis Hopper/Ed Ruscha," Tony Shafrazi Gallery, New York

"Dennis Hopper/William Burroughs," Sena Galleries, Santa Fe, New Mexico

1992–1993

"Proof: Los Angeles Art and Photograph 1960–1980," Laguna Art Museum, Laguna Beach, California; Lincoln, Massachusetts; San Francisco, California; Montgomery, Alabama; Tampa, Florida; Des Moines, Iowa

1995–1996

"Beat Culture and the New America 1950–65," Whitney Museum of American Art, New York; Walker Art Center, Minneapolis, Minnesota; M.H. de Young Memorial Museum, San Francisco

1996

"Hall of Mirrors: Art and Film since 1945," The Museum of Contemporary Art, Los Angeles; Wexner Center for the Arts, Columbus, Ohio; Palazzo delle Esposizioni, Rome; Museum of Contemporary Art, Chicago

"Photographing the L.A. Art Scene 1955–77," Craig Krull Gallery, Santa Monica, California

"Dennis Hopper/Bruce Conner," Gallery Paule Anglim, San Francisco

1997

"Photo Op: Tim Burton, Dennis Hopper, David Lynch, John Waters," The Contemporary Arts Center, Cincinatti, Ohio

"Sunshine & Noir: Art in Los Angeles, 1960–1997," The Museum of Modern Art, Louisiana, Denmark; (international traveling exhibition; final venue) Armand Hammer Museum, UCLA, Los Angeles, California

"1 Minute Scenario: Printemps de Cahors Photography Festival" (curated by Jerome Sans), Museum of Fine Arts, Cahors

"Countenance: Face, Head and Portrait in Contemporary Art" (organized by Galerie Thaddaeus Ropac, Salzburg), Max Gandolph Bibliothek/Mozartplatz, Salzburg

"Dennis Hopper, Bigas Lunas, Peter Greenaway, and Antonio Lopez," Galeria Metropolitana de Barcelona

"Collaboration/Transformation: Lithographs from the Hamilton Press," Montgomery Gallery, Pomona College, California; Fred Jones Jr. Museum of Art, The University of Oklahoma, Oklahoma

"Face à Face, Galerie Thaddaeus Ropac, Paris

"Director's Cut," Thomas Nordanstad Gallery, Stockholm

"Heaven: Public View, Private View" (curated by Joshua Decter et al.), PS1, Long Island City, New York

1998

"Künstlerportraits," Walter Storms Galerie, Munich

"American Playhouse: The Theatre of Self-Representation," The Power Plant, Toronto, Ontario

1999

"Radical Past: Contemporary Art & Music in Pasadena, 1960–1974," Norton Simon Museum of Art, Pasadena, California

"So Far Away, So Close," Encore...Bruxelles/Espace Meridian, Brussels

"Glass: Tocoma To Taos," Tony Abeyta Gallery, Taos, New Mexico

2000

"Urban Hymns," Harriet and Charles Luckman Fine Arts Gallery, Los Angeles

Filmography

director

Chasers, 1993 (US), Morgan Creek
The Hot Spot, 1990 (US), Orion
Backtrack [European title *Catchfire*], 1989 (US), Vestron/Showtime
Colors, 1988 (US), Orion
Out of the Blue, 1980 (Canada/US),
Gary Juvenat Productions/Discovery Films
The Last Movie, 1971 (US), Universal
Easy Rider, 1969 (US),
Pando Company & Raybert Productions/Columbia Tri-Star Pictures

actor

Ticker, production May 2000, Nu Image Films/Artisan Entertainment
10 Commandments, post-production January 2000, Emotional Network, Düsseldorf
Knockaround Guys, post-production 1999–2000, A.L.A. Productions/ New Line Cinema
Jason and the Argonauts, 2000, Nick Willing, NBC Television
Jesus' Son, 2000, Alliance/Lion's Gate
Held for Ransom, 2000, Lee Stanley, Emmett/Furla Productions
The Spreading Ground, 2000, James Burke, Tsunami Entertainment
Luck of the Draw, 2000, Luca Bercovici, Kandice King Productions
The Venice Project, 1999, Robert Dornhelm, Terra Films
The Prophet's Game, 1999, David Worth, Prophet Productions
Bad City Blues, release pending, Michael Stevens, Bad City Pictures
Straight Shooters, 1999 (Euro), Von Thomas Bohn, Perathon Film
Ed TV, 1999 (US), Ron Howard, Universal Pictures
Michaelangel, release pending, William Gove, Arama Entertainment
Tycus, release pending, John Putch, Phoenician Films
Lured Innocence, release pending, Kikuo Kawasaki, Dakota Sky Productions
Meet the Deedles, 1998 (US), Steve Boyum, Disney Pictures
Top of the World, 1998 (US), Barry Sampson, Phoenician Films
Road Ends, 1997, Rick King, PM Entertainment
The Last Days of Frankie the Fly, 1997, Peter Markle, Phoenician Films
Samson & Delilah, 1996, Nicholas Roeg, TNT Original
Space Truckers, 1996, Stuart Gordon, Universal Pictures
The Fine Art of Separating People From Their Money, 1996, directed by Hermann Vaske, Das Werk
Basquiat, 1996 (US), Julian Schnabel, Miramax
Carried Away, 1996 (US), Bruno Barreto, Cinetel/Fine Line
Search & Destroy, 1995 (US), David Salle, October Films
Waterworld, 1995 (US), Kevin Reynolds, Universal
Witch Hunt, 1995 (US), Paul Schrader, Pacific Western Productions/HBO
Speed, 1994 (US), Jan de Bont, Twentieth Century Fox
Boiling Point, 1993 (US/France), James Harris, Warner
Chasers, 1993 (US), Dennis Hopper, Morgan Creek
The Heart of Justice, 1993 (US), Bruno Barreto, Amblin Entertainment/TNT
Red Rock West, 1993 (US), John Dahl, Polygram Filmed Entertainment & Propaganda/Rank Films
Super Mario Bros., 1993 (US), Rocky Morton and Annabel Jankel, Cinergie/HollywoodPictures
True Romance, 1993 (US),Toy Scott, Morgan Creek/Warner
Sunset Heat, 1992 (US), John Nicolella, King Productions/New Line
Nails, 1992 (US), John Flynn, Viacom/Showtime
Crazy About the Movies (documentary), 1991 (US), Robert Guenette, Showtime
Doublecrossed 1991 (US), Roger Young, Green and Epstein/HBO
Eyes of the Storm, 1991 (US), Yuri Zeltser, New Line
Hearts of Darkness: A Filmmaker's Apocalypse, 1991 (US), Fax Bahr and George Hickenlooper
Indian Runner, 1991 (US), Sean Penn, MGM
Paris Trout, 1991 (US), Stephen Gyllenhaal, Viacom/Showtime
Superstar: The Life and Time of Andy Warhol, 1991 (US)
Chattahoochee, 1990 (US), Mick Jackson, Hemdale
Backtrack [European title *Catchfire*], 1989 (US), Dennis Hopper, Vestron/Showtime
Flashback, 1989 (US), Franco Amurri, Paramount
A Hero of Our Time, 1988 (US), Michael Almereyda
Riders of the Storm, 1988 (US), Maurice Phillips, Miramax

The Texas Chainsaw Massacre Part 2, 1988 (US), Tobe Hooper, Cannon

Black Widow, 1987 (US), Bob Rafelson, Laurence Mark/Twentieth Century Fox

Blood Red, 1987 (US), Peter Masterson

O.C. and Stiggs, 1987 (US), Robert Altman

The Pick-Up Artist, 1987 (US), James Toback

River's Edge, 1987 (US), Tim Hunter, Hemdale

Blue Velvet, 1986 (US), David Lynch, DeLaurentiis/DEG Release

Hoosiers, 1986 (US), David Anspaugh, Hemdale/Orion

Straight to Hell, 1986 (US), Alex Cox

My Science Project, 1985 (US), Jonathan R. Betuel, Touchstone and Silver Screen Partners

Running Out of Luck, 1985, Julian Temple

Slaggskampen [*The Inside Mann*], 1984 (Sweden/UK), Tom Klegg

The Osterman Weekend, 1983 (US), Sam Peckinpah, David Panzer/Twentieth Century Fox

The Human Highway, 1982 (US), Bernard Shakey

King of the Mountain, 1981 (US), Noel Nossek

Ranacida [*Reborn*], 1981 (Spain/US), Bigas Luna

Rumble Fish, 1981 (US), Francis Ford Coppola, Zoetrope Studios/Universal

White Star, 1981 (Germany), Roland Klick

Out of the Blue, 1980 (Canada/US), Dennis Hopper, Gary Jules Juvenat Prods/Discovery Films

Apocalyps Now, 1979 (US), Francis Ford Coppola, Omni Zoetrope/UA

Couleur Chair, 1978 (Belgium), François Weyergans

L'ordre et la sécurité du monde, 1978 (France), Claude D'Anna

Les apprentis sorciers, 1977 (France), Edgardo Cozarinsky

Der amerikanische Freund [*The American Friend*], 1977 (Germany), Wim Wenders, New Yorker Films

Mad Dog Morgan, 1976 (Australia), Philippe Mora

Tracks, 1976 (US), Henry Jaglom, International Rainbow Pictures and Dumont/Trio

Blood Bath (aka *The Sky Is Falling*), 1975

James Dean: The First American Teenager, 1975 (UK), Ray Connolly

Kid Blue, 1973 (UK), James Frawley, Marvin Schwarz Productions/Twentieth Century Fox

The American Dreamer, 1971 (US), Lawrence Schiller & L.M. Kit Carson, Corda Prods/EYR

Crush Proof, 1971 (US), François de Ménil

The Last Movie, 1971 (US), Dennis Hopper, Universal

Easy Rider, 1969 (US), Dennis Hopper, Pando Company and Raybert Prods/Columbia Pictures

True Grit, 1969, Henry Hathaway, Hal B. Wallis/Paramount Pictures

Head, 1968 (US), Bob Rafelson, Columbia Pictures

Cool Hand Luke, 1967 (US), Stuart Rosenberg, Jalem/Warner Bros.

The Glory Stompers, 1967 (US), Anthony M. Lanza

Hang 'em High, 1967 (US), Ted Post, Malposo/United Artists

Luke, 1967 (US), Bruce Conner

Panic in the City, 1967 (US), Eddie David

The Trip, 1967 (US), Roger Corman, American International Pictures

Queen of Blood (aka Planet of Blood), 1966 (US), Curis Harrington

The Sons of Katie Elder, 1965 (US), Henry Hathaway, Hal B. Wallis/Paramount Pictures

Night Tide, 1963 (US), Curtis Harrington, Virgo Films

Tarzan and Jane Regained... sort of, 1963 (US), Andy Warhol

Key Witness, 1960 (US), Phil Karlson

The Young Land, 1959 (US), Ted Tetzlaff/Columbia Pictures

From Hell to Texas, 1958 (US), Henry Hathaway, Twentieth Century Fox

The Story of Mankind, 1957 (US), Irwin Allen, Cambridge/Warner Bros.

Giant, 1956 (US), George Stevens, Warner Bros.

Gunfight at the OK Corral, 1956 (US), John Sturges, Paramount Pictures

The Steel Jungle, 1956 (US), Walter Doniger

Died a Thousand Times, 1955 (US), Stuart Heisler, Warner Bros.

Rebel Without a Cause, 1955 (US), Nicolas Ray, Warner Bros.

Selected Bibliography

monographs/exhibition catalogues

Ammann, Jean-Christophe. *Dennis Hopper: Fotografien von 1961 bis 1967.* Basel: Kunsthalle Basel, 1988.

Ayres, Anne. *Forty Years of California Assemblage.* Los Angeles: Wight Art Gallery, University of California at Los Angeles, 1989.

Ayres, Anne, et al. L.A. *Pop in the Sixties.* Newport Beach, California: Newport Harbor Art Museum, 1989.

Barbera, Alberto, Sara Cortelazzo and Davide Ferrario. *Dennis Hopper – il cinema.* Turin: Assesorato per la Cultura, AIACE Turin, 1988.

Brogher, Kerry. *Art and Film Since 1945: Hall of Mirrors.* Los Angeles: Museum of Contemporary Art, 1996.

Collaboration/Transformation. Group exhibition catalogue, essay by Dave Hickley, Montgomery Gallery, Pomona College (traveled to Fred Jones Jr. Museum of Art, The University of Oklahoma).

Coplans, John. *Los Angeles Now.* London: Graphis Press Limited/ Robert Fraser Gallery, 1966.

Darling, Michael. *Dennis Hopper: Italian Walls.* Milan, Palazzo Marino alla Scala Art Center, 1997. Sponsored by Fondazione Trussardi.

Desmarais, Charles. *Proof: Los Angeles Art and the Photograph 1960-1980.* Laguna Beach, California: Laguna Art Museum, 1992.

Hoberman, Jim. *Dennis Hopper: From Method to Madness.* Minneapolis, Minnesota: Walker Art Center, 1987.

Dennis Hopper: Bad Heart: Fotografies i pintures 1961–1993. Barcelona: Universitat Pompeu Fabra, 1993.

Hopper, Dennis, "Into the Issue of the Good Old Time Movie Versus the Good Old Time", introduction to *Easy Rider*, edited by Nancy Hardin and Marilyn Schlossberg, including the original screenplay by Peter Fonda and Terry Southern. New York: Signet Books, the New American Library, Inc. 1969, pp. 7-11.

Hopper, Dennis and Shintaro Katsu. *Dennis Hopper: A Tourist.* Kyoto: File, Inc., 1994.

Krull, Craig. *Photographing the L.A. Art Scene 1955–1975.* Santa Monica, California: Smart Art Press, 1996.

Metzger, Rainer. *Countenance: Face, Head, and Portrait in Contemporary Art.* Gallery Thaddaeus Ropac, Salzburg/Paris, 1997.

Phillips, Lisa et al. *Beat Culture and the New America 1950–1965.* New York: The Whitney Museum of American Art, 1995.

Schulz, Berndt. *Dennis Hopper: Schauspieler/Regisseur/Fotograf.* West Germany: Gustav Lubbe Verlag, 1990.

Tanikawa, Takeshi. *Dennis Hopper: Legend of the Survivor.* Tokyo, 1995.

Tanikawa, Takeshi. *The Man Who Created Easy Rider.* Tokyo, 1996.

general books

Burke, Tom. "Dennis Hopper Saves the Movies." In: *Burke's Steerage.* New York: G.P. Putnam's Son, 1976, pp. 115-134 (reprinted from *Esquire*, September 1970, pp. 139-141).

Cagin, Seth and Philip Draw. *Hollywood Films of the Seventies*, New York: Harper & Row, 1984, pp. 41-74.

Crow, Thomas. *The Rise of the Sixties: American and European Art in the Era of Dissent.* New York: Harry N. Abrams, Inc., 1996, pp. 78-81.

Gallagher, John Andrew. "Dennis Hopper." In: *Film Directors on Directing.* New York: Carol Publishing Group, 1991, pp. 63-75.

Hickenlooper, George. "Dennis Hopper: Art, Acting and the Suicide Chair." In: *Reel Conversations: Interviews with Films Foremost Directors and Critics.* New York: Carol Publishing Group, 1991, pp. 63-75.

Hopper, Dennis. Introduction to *James Dean: Behind the Scene.* Edited by Leith Adams and Keith Burns. New York: Carol Publishing Group, 1990, pp. 8-12.

Hopper, Dennis, Michael McClure and Walter Hopps. *Dennis Hopper: Out of the Sixties.* Photos by Dennis Hopper. Pasadena, California: Twelvetrees Press, 1986.

Pedersen, Martin (Ed.). *Graphis Photo 97.* Toppan, Hong Kong, 1997, pp. 18-19.

Rudnick, Lois Palken. *Utopian Vistas: The Mabel Dodge Luhan House and the American Counterculture.* Albuquerque, New Mexico: University of New Mexico Press, 1996, pp. 185-284.

Siska, William Charles. "Formal Reflexivity in Dennis Hopper's *The Last Movie*." In: *Modernism in the Narrative Cinema: The Art Film as Genre.* Unpublished PhD dissertation, New York University, pp. 80-100.

articles / interviews

Algar, Nigel. "Hopper at Birmingham." *Sight and Sound*, Vol. 51, No. 3 (Summer 1982), p. 150.

The American Film Institute Harold Lloyd Master Seminar. Transcript of discussion with Dennis Hopper moderated by Ron Silverman, February 15, 1995.

Archibald, Lewis. "An Interview with Dennis Hopper: Is the Country Catching Up to Him?" *The Aquarian* (April 20, 1983), p. 8.

Assayas, Oliver. "Dennis Hopper revient à Cannes." *Cahiers du Cinéma*, No. 214 (June 1980), pp. iii-iv.

Bruce, Bryan. "Rap/Punk/Hollywood: Beat Street and Out of the Blue." *CineAction!* (Spring 1985), pp. 6-11.

Burke, Tom. "Dennis Hopper Saves the Movies." *Esquire*, September 1970, pp. 139-141 (republished in Burke, Tom. *Burke's Steerage.* New York: G.P. Putnam's Son, 1976, pp. 115-134).

Carcassonne, Philippe. "Rencontre avec Dennis Hopper." *Cinématographe*, no. 68 (June 1981), p. 77.

Chadwick, Susan. Exhibition review, Davis/McClain Gallery: "Photographer with a cause documents cultural era." *The Houston Post* (Saturday, February 24, 1990).

Chaillet, Maurice. "Dennis Hopper: Out of the Sixties." *Première*, June 1987, pp. 100-104.

Clothier, Peter. "Dennis Hopper at James Corcoran." *Art in America*, June 1992.

Clothier, Peter. "Hip Hopper." *Art News*, September 1997, pp. 124-127.

Combs, Richard. "The Last Movie." *Monthly Film Bulletin*, Vol. 49, No. 585 (October 1982), pp. 218-219.

Dalchow, Paula. "Der Fiesling und die Poesie." *Elle*, June 1996, p. 44-46.

Darrach, Brad. "The Easy Rider in the Andes Runs Wild." *Life*, June 19, 1970, pp. 49-59.

Drohojowska, Hunter. "Ruscha Today." *LA Style*, June 1990. Portrait by Dennis Hopper.

Ebert, Roger. "Out of the Blue, an unforgettable poem." *Chicago Sun-Times* (November 17, 1982).

Enwezor, Okwui. "Basquiat." *Frieze*, issue 32 (January/February 1997), pp. 82-83.

Factor, Donald. "Assemblage." *Artforum*, Summer 1964, illus. by Dennis Hopper.

Fischer, Jack. "Silent Pictures." *San Jose Mercury News* (July 18, 1997).

Goodwin, Michael. "In Peru with Dennis Hopper making *The Last Movie.*" *Rolling Stone* (April 16, 1970), pp. 26-32.

Green, Robin. "Confessions of a Lesbian Chick: A Penetrating Interview with Dennis Hopper." *Rolling Stone* (May 13, 1971), pp. 34-36.

Hadenfield, Chris. "Citizen Hopper." *Film Comment*, Vol. 22, No. 6 (November/December 1986), pp. 62-73.

Hainly, Bruce. "Dennis Hopper at Fred Hoffman Fine Art." *Artforum*, October 1997, pp. 105-106.

Henschel, Regine C. "Dennis Rides Again." *Kultur News*, August 1997.

Hindry, Ann. "Cinema & Art: Dennis Hopper." *Galeries Magazine* (international edition), No. 51 (October/November 1992), pp. 88-93.

Hopkins, Henry T. "Dennis Hopper's America." *Art in America*, May/June 1971, pp. 80-91.

Hopper, Dennis and Quentin Tarantino (interview). "Blood Lust Snicker in Wide Screen." *Grand Street* 49, Vol. 13, No. 1 (Summer 1994), pp. 10-22.

Hopper: His Art and Movies: Silverstar Club 13, (1990), complete issue.

Hopper, Dennis. "Light Years from Home." *LA Style*, November 1989.

Hopper, Dennis. "Standard Bullshit." *Parkett*, No. 18 (December 1988), pp. 48-53, a series of photographs by Dennis Hopper selected for the Ed Ruscha issue.

"Dennis Hopper with Tony Shafrazi." *Index Magazine*, May/June 1999, pp. 52-64.

James, David E. "Dennis Hopper's *The Last Movie.*" *Journal of University Film and Television Association*, Vol. XXXV, No. 2 (Spring 1983), pp. 34-46.

James, David E. "Hall of Mirrors: Art and Film Since 1945." *Art + Text*, No. 54 (May 1996).

Kandel, Susan. "Troubling Flashbacks From Dennis Hopper." *Los Angeles Times* (June 13, 1997), Section F, p. 12.

Kaprow, Allen. "The Happenings are Dead." *Artforum*, March 1966, photos by Dennis Hopper.

LaSalle, Mick. "Dennis Hopper's Artier Side." *San Francisco Chronicle*, September 29, 1996, Datebook section, pp. 42-43.

Leider, Philip. "Regional Accent: California After the Figure." *Art in America*, Vol. 51, No. 5 (October 1963).

McMillian, Elizabeth and Dennis Hopper. "Artist in Residence." *Southland*, Spring/Summer 1999, pp. 57-65.

Penn, Sean, Robert Duvall and Dennis Hopper. "Colors." *City, Helsingin Kuukausilehti*, July 1988, pp. 8-10.

Petley, Julian. "Dennis Hopper." *Stockholm Film Festival 1991*, pp. 148-175.

Quinn, Joan Agajanian. "Road's Scholar: Dennis Hopper." *Interview*, December 1985, p. 238.

Rugoff, Ralph. "Lost at the Mall. Searching for the intersection of art and film." *LA Weekly*, March 29-April 4, 1996.

Schonholz, Manuela. "Blick für das Gewohnliche." *Feuilleton* (June 24, 1997).

Schwefel, Heinz Peter. "Dennis Hopper. Ein Mann stellt die Bilder in Frage." *Art. Das Kunstmagazin*, December 1997, pp. 74-83.

Selwyn, Marc. "Dennis Hopper." *Flash Art International*, No. 147 (Summer 1989), pp. 118-121.

Southern, Terry. "The Loved House of the Dennis Hoppers." *Vogue* (August 1, 1965), pp. 137-142.

Squire, Corinne. "Out of the Blue and Into the Black: A Psychoanalytic Reading." *Screen*, Vol. 23, No. 3-4 (September/October 1982), pp. 98-106.

Uyeda, Seiko. "Quest for Lost Image." *Seven Seas*, No. 113 (January 1998), pp. 171-175.

Toshinori, Arai, photographs by Kazumi, Kurigami. "Director's Note." *Switch*, Vol. 15, No. 5 (June 1997), pp. 24-43, pp. 60-65.

White, Garrett and Robert Dean. "Art of the Sixties: Another Side of Dennis Hopper." *Frank*, No. 8/9 (Winter 1987/88), pp. 24-32.

White, Garrett and Robert Wilmington. "Citizen Rebel: Somewhere in the Middle with Dennis Hopper." *LA Style*, July 1989. Photographs by Herb Ritts.

White, Garrett and Michael Lassell. "Unconventional Perspectives." *LA Style*, June 1989.

Wholden, R.G. "Assemblages at Primus/Stuart." *Artforum*, Vol. 1, No. 10 (April 1963).

Wilson, William. "More Than Meets the Eye." *Los Angeles Times* (January 14, 1992), calendar section.

colophon

This publication appears on the occasion of the exhibition
"Dennis Hopper" in the Stedelijk Museum Amsterdam,
17 February – 16 April 2001.

acknowledgements:
Julia Paull and Karen Freedman, Alta Light Productions, Venice, CA
Fred Hoffman Fine Art, Santa Monica, CA

translation Dutch-English: Beth O'Brien, Eindhoven
graphic design: Anthon Beeke/Paulina Matusiak,
Studio Anthon Beeke bv, Amsterdam
production: Astrid Vorstermans, NAi Publishers, Rotterdam
copy editing: Els Brinkman, Amsterdam
publisher: Stedelijk Museum Amsterdam/NAi Publishers, Rotterdam
lithography and printing: drukkerij Mart.Spruijt bv, Amsterdam

Unless stated otherwise, works are owned by the artist.
Sizes works
1 inch = 2.54 cm
1 foot = 30.48 cm

© Photographs: Dennis Hopper/Alta Light Productions, Venice, CA
except: p. 8-16, Rudi Fuchs, Amsterdam
*cover: Within a man of light, there is only light; within a man of darkness,
there is only darkness (Self Portrait)*, 1997 (detail)
digital ink jet print transparency and lightbox
36 x 48 x 5 inches

Available in North, South and Central America through D.A.P./
Distributed Art Publishers Inc, 155 Sixth Avenue 2nd Floor, New York,
NY 10013-1507, Tel. 212 6271999, Fax 212 6279484.

Available in the United Kingdom and Ireland through Art Data,
12 Bell Industrial Estate, 50 Cunnington Street, London W4 5HB,
Tel. 181 7471061, Fax 181 7422319.

Printed and bound in the Netherlands

Stedelijk Museum cat. nr. 851
ISBN 90-5662-195-5